# ON
# FAMILY

The joys and challenges of family life
*A Photographic Project*

Published in 2024 by The School of Life
First published in the USA in 2024
930 High Road, London, N12 9RT

Copyright © The School of Life 2024

Photography © Kate Peters, © Mark Hobbs, © Marjolaine Ryley,
© Michelle Sank, © Naomi Williams
Photography commissioned in association with Camilla Brown,
a curator, writer and educator on contemporary art, specialising
in photography. She is programme leader of MA photography
at Middlesex University, focussing on contemporary social
documentary practice.

Designed and typeset by Marcia Mihotich
Printed in Lithuania by Balto Print

A proportion of this book has appeared online at
www.theschooloflife.com/articles

The School of Life publishes a range of books on essential topics in
psychological and emotional life, including relationships, parenting,
friendship, careers and fulfilment. The aim is always to help us to
understand ourselves better – and thereby to grow calmer, less
confused and more purposeful. Discover our full range of titles,
including books for children, here: www.theschooloflife.com/books

The School of Life also offers a comprehensive therapy service,
which complements, and draws upon, our published works:
www.theschooloflife.com/therapy

www.theschooloflife.com

ISBN 978-1-915087-41-6

10 9 8 7 6 5 4 3 2 1

# ON
# FAMILY

The School of Life

# INTRODUCTION

## A FATEFUL SUSCEPTIBILITY

The official story about families is that they are joyful, comforting and safe. They are where we should turn in moments of crisis; they nourish and understand us; they deserve to be thought of as close to the meaning of our lives.

The idea is tender and profoundly seductive; but that does not – of course – guarantee it is true. For every devotee of mum or dad, for every parent who feels sincerely proud of, and connected to, their offspring, for every octogenarian who can with honesty say that the effort of producing another generation was wholly worth it, there are legions more who – in the silence of their hearts – confusedly wonder why their experience of family life has turned out to be so much more complicated than it was supposed to have been.

We lack easy access to knowledge of what is real and typical about families. How do other people experience them? Is anyone else going through the kind of turmoil and ambivalence we may know? What is meant to be normal here?

The answers we receive skew towards sentimentality and evasion. No one quite wants to admit to the complexities. As a result, we keep being led to believe that our own sadder or more entangled stories must be the freakish and anomalous ones: though we may have suffered badly at the hands of a mother or father, surely mothers and fathers in general are admirable and kind? We may have lived through a lot of scratchy times around our children or siblings, our cousins or aunts, but, we may insist, families as a whole must ultimately be the repositories of the shelter and intimacy they are associated with.

In some moods, we might feel that it would be easier to avoid the rigmarole of family altogether: if we could somehow be ejected from a machine after a nine-month gestation, or could, like a foal, stand up and wander off on our own thirty minutes after birth – or like a golden eaglet, make it to maturity in just twelve weeks. Our long gestation exposes our species far more than is common in the animal kingdom to the extraordinary quirks and vagaries of our home environments. It probably wouldn't matter overly if a baby turtle's mother was emotionally detached or if a golden eagle's dad had a propensity to humiliate or get violent. But our species takes parental failings much more to heart. An unfortunate time between the ages of 1 and 9 has the power to unbalance a whole life; a depressive parent can permanently sap a child's energy to succeed, an alcoholic one can forever destroy trust and calm.

It can be twenty years or more until a human is able to make their own bed or face life unaided – and in that period, we tend to grow profoundly enmeshed with people whose temperaments are likely to be in part highly damaged and will therefore need to be decoded over many years of subsequent reflection. These people – who teach us to speak and to spoon our yogurt – are also constantly feeding us 'scripts' about who we are, what we can expect of the world, what relationships are like and what we are allowed to hope for, scripts filled with idiosyncrasies and biases that can hamper our efforts at self-awareness and fulfilment. Our families lend us an emotional language that lodges itself as firmly and imperceptibly in us as our mother tongue, a language about love, self-esteem, sexuality, gender, money and entitlement, which we may struggle ever to shed in the name of a fairer, more logical idiom.

The only families we can think of as normal are those we don't yet know very well. It's a touching moment when a young adolescent

realises, for the first time, that their family might be somewhat crazy. They are rarely wrong for thinking so; their error lies in a touching attachment to the idea that *other* families – those of their school friends, for example – might be sane. We might be deep into middle age before we are ready to recognise the essential folly of our race. When it comes to family, we should never compound our own particular problems by mistakenly categorising them as being – on top of everything else – exceptional.

## THE ROLE OF ART

Sentimental silence about complicated issues is one reason why we need works of art. These works reach an apogee of utility when they fulfil a basic, often unheralded, function: that of telling us what's really going on in the lives of other people.

Most of those who surround us are exquisitely fake in what they tell us. They boast about the amusing holidays they've been on, they carefully disguise the breakdowns and the rage that go on in their kitchens and bedrooms, they let out only the merest hints about the misery stirring beneath an upbeat surface. They're only trying to protect themselves from despair but, in the process, they make life mightily difficult for everyone, enforcing a code of mutual silence and shame that ends up imprisoning us all.

The School of Life commissioned five UK-based photographers to go out into their country and collect realistic data about family life. The questions they asked were deliberately simple in structure: Would you tell us how you experience family? How have been your relationships with your mums and dads, sons and daughters? What's really going on for you? What have been the significant moments? Where are the joys and what causes pain? What are the

resentments? Where is the love? How might you heal? What are the answers?

The result is a compendium of voices across genders, economic classes, regions and ages, united by a common concern: how do we cope with the realities of family life?

We are likely to put the volume down stirred by how much unites us; and at moments, touched by our common sources of suffering, less alone with our woes, and readier to reach out to our similarly confused neighbours and to say: *I know, I know.*

The point of these images is to situate our concerns on a wider canvas and to motivate us to understand and solve some of what threatens our hopes.

This is art in the service of emotional education.

### THE MISSION

Here is some of what the book might achieve:

1.     We can be helped to realise that we are not alone in our suffering, and given an experience of the ocean of pain we swim in.

2.     We may be – though it sounds paradoxical – pleased that others are suffering. We're not being cruel; we're looking to feel that we have not been individually cursed. The official stories we have heard aren't usually the normal or true ones.

3.     We can sense afresh just how much influence parents have on their children and children have on their parents. Both sides can destroy each other's lives, though – because of the imbalance of power – it is generally the elders who put greater energy into the business of scrambling their offspring. We should never underestimate how powerful the influence can be: an unfortunate father or mother can

ensure, by the time their offspring is 10, that the child will never know a day of happiness again.

4.      We are reminded of how helpless we are before the powerful imprinting we receive at the hands of parents. Families are our destiny. We will have performed a near miracle if we manage to free ourselves from their influence to an even minor degree over the course of our whole lives.

5.      We can walk away with newfound sympathy for our fellow humans. We can't know what their family story will be, but we can be sure that there is one, and that it will – at least in part – be one of immense hardship and sadness. We should go easy on one another; we're all – in a fascinating variety of ways – walking wounded.

6.      We are unlikely to be photographers, but we can take from these examples a more general lesson about the need for curiosity and imagination. Even without a camera, 'Would you tell me about your family?' is one of the most interesting questions we can ever ask of another human. Inspired by this book, we might, in a private way, assemble comparable entries in our minds, asking those we meet to share with us some of the sorrows and joys of their inevitably complicated upbringings, to reduce the burden of shame and loneliness and to use the material to cement true friendship.

7.      Finally, the point of the book is to help us reflect on our own family experiences with newfound candour and courage. The stories of others promise to sharpen our perspective on our particular trajectories. We'll know ourselves better through meditating on what strangers have been through. We are – in a sense – the true subjects of this work.

To risk a generalisation: almost all the emotional illnesses within families can be traced back to an absence of love. Somewhere down the line, someone wasn't there for someone, someone didn't listen, someone was cold, vengeful or (at worst) violent. And, as a result, there is neurosis and low self-esteem, self-harm and paranoia, sadness and bitterness.

Our societies sometimes make generalisations about so-called 'privileged childhoods': we associate the term with a swimming pool in the garden, holidays abroad and lavish presents – and maybe someone deferential picking up the clothes from the bedroom floor during school hours. Our ideas are plainly focused on money.

The idea has enough truth in it to convince the cynical parts of us, but the number of breakdowns and mental illnesses gnawing at the upper classes should be enough to force us to concede that money cannot on its own be the reliable guarantor of 'privilege' that it would, in a way, be simpler to imagine it was.

True privilege is an emotional phenomenon. It involves receiving the nectar of love – which can be stubbornly missing in the best-equipped mansions and oddly abundant in the bare rooms of modest bungalows.

It is true privilege when a parent is on hand to enter imaginatively into a child's world; when they have the wherewithal to put their own needs aside in order to focus on the confusions and fears of their offspring; and when they are attuned not just to what a child actually manages to say but to what they might be aspiring yet struggling to explain.

It is privilege when a parent lends us a feeling that they are loyal to us simply on the basis that we exist rather than because of anything

extraordinary we have managed to achieve; when they can imbue us with a sense that they will be on our side even if the world has turned against us; and when they can teach us that all humans deserve compassion and understanding despite their errors and compulsions.

It is privilege when parents can shield us from the worst of their anxiety and rage and the full conflicts of their adult lives; when they can respect the fact that it is many years before a child is old enough to face the full complexity of existence – and when they are sufficiently mature to let us grow up slowly.

It is privilege when parents don't set themselves up as perfect or, by being remote and unavailable, encourage us to idealise or demonise them. It is privilege when they can be ordinary and a little boring, can invite us to develop into a man or a woman beside them – and can know how to let themselves be superseded.

It is privilege when parents can bear our rebellions and don't force us to be preternaturally obedient or good, when they don't crumple if we try out what it feels like to call them old idiots, and when they themselves reliably seek to explain, rather than impose, their ideas.

It is privilege when they can accept that we will eventually need to leave them and not mistake our independence for betrayal.

All of these moves belong to privilege sincerely understood, and they are, at present, about as rare as huge wealth, but at points more crucial. It is those who have enjoyed years of emotional privilege who deserve to be counted among the true one per cent.

It can be natural, when we meet with any sort of privilege that has been deeply and unfairly distributed, to seek to level the playing field. But it can't be a redistribution of privilege that is required here, but rather a universal increase – and the assurance of a decent minimum.

A truly fair society would be one in which a yearly rise in the degree of emotional privilege in circulation would become a national priority – and where an abundance of love, concern, and connection was adequately studied, encouraged and prized as the true 'wealth' it is.

## A ROLE FOR PSYCHOTHERAPY

This book is deeply indebted to the ideas of psychotherapy – and sees the discipline as one of the finest correctives to the problems we meet in these pages.

A founding idea of psychotherapy is that we tend to suffer – to get mentally unwell, have a breakdown or develop phobias – because we are not sufficiently aware of the difficulties we have been through in our families of origin. Somewhere in the past, we have endured certain situations that were so troubling or sad, they outstripped our rational faculties and had to be pushed out of day to day awareness. For example, we can't remember the real dynamics of our relationship with a parent; we can't see what we do every time someone tries to get close to us, nor trace the origins of our self-sabotage or panic around sex. Victims of our unconscious, we can't conceive what we have longed for or been terrified by.

Psychotherapy promises to be a tool for correcting our self-ignorance – and liberating ourselves through knowledge. It provides us with a space in which we can, in safety, say whatever comes into our heads. The therapist won't be disgusted or surprised or bored. They have seen everything already. In their company, we can feel acceptable and our secrets can be sympathetically unpacked. As a result, crucial ideas and feelings bubble up from the unconscious and are healed through exposure, interpretation and contextualisation.

We cry about incidents we didn't even know, before the session started, we'd been through or felt so strongly about. The ghosts of the past are seen in daylight and are laid to rest.

Transference is a technical term that describes the way, once therapy develops, a patient will start to behave towards the therapist in ways that echo aspects of their most important and most traumatic past relationships.

A patient with a punitive parent might – for example – develop a strong feeling that the therapist must find them revolting, or boring. Or a patient who needed to keep a depressed parent cheerful when they were small might feel compelled to put up a jokey facade whenever dangerously sad topics come into view.

We transfer like this outside therapy all the time, but there, what we're doing doesn't get noticed or properly dealt with. However, therapy is a controlled experiment that can teach us to observe what we're up to, understand where our impulses come from – and then adjust our behaviour in less unfortunate directions. The therapist might gently ask the patient why they're so convinced they must be disgusting. Or they might lead them to see how their use of jokey sarcasm is covering up sadness and terror.

The patient starts to spot the distortions in their expectations set up by their history – and develops less self-defeating ways of interacting with people in their lives going forward.

We are, many of us, critically damaged by the legacy of past bad relationships. When we were defenceless and small, we did not have the luxury of experiencing people who were reliable, who listened to us, who set the right boundaries and helped us to feel legitimate and worthy.

However, when things go well, the therapist is experienced as the first truly supportive and reliable person we've yet encountered.

They become the good parent we so needed and never had. In their company, we can regress to stages of development that went wrong and relive them with a better ending. Now we can express need, we can be properly angry and entirely devastated and they will take it – thereby making good of years of pain.

One supportive relationship becomes the model for relationships outside the therapy room. The therapist's moderate, intelligent voice becomes part of our own inner dialogue. We are cured through continuous, repeated exposure to sanity and kindness. We experience some aspects of the family we never had.

### WHAT REALLY WENT ON IN MY CHILDHOOD?

If the idea at the heart of modern psychotherapy is that in order to heal ourselves from our neuroses in the present we need to understand the past, there is one enormous problem: amnesia. Simply put, almost no adult remembers very much that happened to them before they were 3 years old: countless days and nights, a succession of complicated moods, sensations and events will have vanished into thin air, like a library of precious books that has gone up in smoke or been dumped unceremoniously into the sea. Furthermore, most of us remember very little of what went on before we were 7. This may seem like an obvious point, but it has momentous implications. A period that we've identified as extremely central is also going to be entirely nebulous.

Another basic fact of every childhood is that even though the past may have been extremely strange and regrettable, it will also – in key ways – now seem rather normal and beyond easy analysis or questioning. Our childhood is – quite literally – what we've grown up with and, as we know, what has always been around has a habit of

not signalling its oddity. We might sense that something was peculiar around our caregivers, but to really get a proper understanding of what these people were up to tends to be far beyond our ordinary powers. We prefer to think of something else – and to run fast in an opposite direction.

But there is one useful way to make progress: we should look at ourselves in the present. Everything we need to know of the past is contained in what's going on for us right now. We don't need to try to remember all sorts of things that have in reality escaped us; we just need to check in on who we are today. The legacy of the past will be active, rich and vibrant (for better and for worse) at every moment of our adult lives.

One of the first questions we need to ask ourselves – as archaeologists of our pasts – is what, day to day, in the adult realm, we are afraid of.

Imagine someone being asked to make a list of sentences that all begin with 'I'm terrified of…'. Honestly written, the list might look like this:

> – *I'm terrified of being thought an idiot.*
> – *I'm terrified of being found ugly and unacceptable.*
> – *I'm terrified of being arbitrarily humiliated,*
>  *mocked and rejected.*
> – *I'm terrified that people will be extremely nasty to me.*

What we dread at the hands of everyone we meet nowadays will inevitably be a version of what we once feared at the hands of very specific caregivers in a very specific and yet very forgotten childhood.

This gives us a huge amount to go on; indeed, it offers us nothing less than the tools for our recovery. We can make our own

lists and use them as an archaeological map to guide our thinking. The self-questioning might go like this:

– *Someone terrified you of being an idiot: who might it have been and how did it happen?*
– *Someone found you ugly and unacceptable: what might have occurred here?*
– *Someone has, it seems, arbitrarily humiliated, mocked and rejected you: does that ring any bells?*
– *Someone probably gave you an experience of extreme nastiness: is this somehow familiar?*

Though we might not be used to thinking in this way, with such prompts at hand, rich and vibrant thoughts may rise up from the unconscious. We might get a new perspective on our caregivers and on what we underwent. Framed in this way, we might see with newfound clarity that quite a lot more was going on in those early days than we generally like to imagine.

What will be the next step? We'll need to go back over the past, with a lot of patience and courage, while also bearing in mind that what we have been projecting willy nilly onto every man and woman in the present, and every difficulty we face in the here and now actually had very particular origins. The more we understand those origins, the more we'll feel liberated from them and unburdened by them.

Our future won't have to feel so constantly difficult or fear-laden once we trace back its real difficulties to a point of origin. Remembering will set us free.

One of the most continuously fascinating ideas for understanding ourselves is the concept of projection. What this means, simply put, is that all of us have a storehouse of assumptions about what other people are like and how they will behave, which owes very little to actual people who we meet today and a lot more to do with complications in our childhoods that we have generally forgotten about.

Furthermore, these projections tend to be distinctly and unfruitfully negative: we think worse of people than we should, we are quicker to be afraid, to be angry and to be uncooperative than we need to be, because our imaginations are filled with dark experiences that reflect our painful origins and yet fail to do justice to a broader, more innocent, more hopeful present. As a result, our projections gum up our relationships with the world around us. We arrive in the presence of others with a great deal more aggression, suspicion, fear or doubt than is warranted in the here and now.

The theory of projection sounds simple and plausible enough. The difficulty is that it is extremely hard to work out what it is we are actually projecting. We are far too much inside ourselves to see our own biases. We can't tell how we're distorting our assessments of others; there's no gap between our judgements and our reason.

Yet we stand to make some progress through a simple exercise that involves a little reflection on our most characteristic assumptions of other people taken as a whole. In a quiet, reflective mood, we should title a blank sheet of paper: *What I Expect Other People Will Be Like* – and then see what comes up for us.

A list might look like this:

*– Older men in authority are judgemental and angry.*
*– Other people can suddenly turn around and viciously attack you.*
*– People only respect money and status.*
*– Nice people aren't very competent or worthy of respect.*
*– People can't be relied upon to help when you need them.*
*– People might be laughing or silently ridiculing.*

The list might – to an extent that surprises us – be extremely negative. Now the next question should be: why are we thinking this way? Common sense tells us: because this is what reality is like. But the more therapeutic line counters: because this is what our childhood was like and that is what has unconsciously influenced, and poisoned, our assessment of all strangers in the present.

In order to honour the true complexity as well as hopefulness of the world as it is now, we should then ask which specific individuals from our past might be held responsible for inspiring our panoply of particular, and particularly dark, assumptions. Beside every generalisation on our sheet of paper, we should – with a different-coloured pen – write down a particular name who might have inspired an especially caustic assessment of humanity.

If we've had a certain sort of childhood, we should in time be able to arrive at a definite set of names and memories. Once we start to explore, we'll see that a statement like 'Older men in authority are judgemental and angry' really relates to a very particular man in a very particular moment, while the unhelpful idea that no one can be relied upon is the sediment of an earlier situation in which specific people didn't help us when we badly needed them to have done so.

There are few things harder to see than our biases, but we can – with the help of exercises – learn to free ourselves from some of their

more vicious, though invisible, tentacles. Other people can often be extremely difficult, of that there is no doubt, but to an extent that may well surprise us, it isn't really people 'in general' who are the problem. It's almost certainly people in particular who troubled us a long time ago and who we've taken great care to forget all about.

We may have a lot more faith in humanity once we can be more forensic and sad about a few key figures in the past.

### TRIGGERING AND CHILDHOOD

The concept of being triggered, though it may at times be overused, sits on top of a hugely important concept in psychological life that demands our respect, compassion and attention. To be triggered is, in its most basic form, to respond with intense fear and anger to a situation in the here and now that, to other people, may seem blameless and unconcerning. One moment we are calm, the next we are catapulted into despair and terror; only minutes ago, the future looked hopeful, now only ruin and disaster seem to lie ahead.

Most of us who suffer from these episodes would very much like to be better able to hold on to equanimity and hope. It may be important to know how to be scared or incensed when situations actually demand it, but – the triggered person typically feels after an episode – it is also deeply counterproductive and plain exhausting to be visited by powerful emotions that aren't warranted by what lies before us and that fail to advance our interests in any way.

The way out of being uncontrollably triggered is to understand how the mechanism operates. The mind is triggered when it believes it recognises in the world around it a situation that it feels from memory to be highly damaging and dangerous. Our triggers are a secret guide to our histories; they tell us about things we were once

very afraid of. The triggering element is like a piece of a jigsaw that will precisely fit into an analogous puzzle in the past. We are triggered now by what we were devastated by then.

Even if we don't remember too much about our past, we can surmise everything we need to know from reverse engineering our triggers. If we are constantly afraid we are going to be excommunicated and mocked, this will – in some form – be exactly what happened to us at some stage long ago. If we're terrified that someone is going to overpower us and not listen to our 'no's', this is an almost sure echo of what we once experienced. The precise relationship between trigger and catalytic event may not always be literally equivalent (there can be some displacement along the way), but the link will be strong all the same. The trigger contains and maps onto a traumatic event.

Let's imagine a person who is triggered – that is, thrown into powerful despair and self-loathing – by images on social media of blatantly attractive and popular people. No sooner have they seen these than they start to doubt and despise themselves, reflect on their inadequacies and remember all the reasons why they are fated to be a failure and unloved.

The trigger is not entirely 'nothing'. There *is* something a little dispiriting about the beauty parade on certain sorts of social media. But the point at issue is the scale of the reaction that is generated. In seeking to account for it, we have to look backwards. The person has been triggered because the contemporary event contains, in a garbled, disguised and unconscious form, the essence of a profoundly traumatic dynamic in earlier life that lies mostly unknown and unexplored – and thereby commands immense and unending power over the victim.

Let's suppose that this person had a mother who favoured their more ebullient younger sibling over them and that their looks

were part of what damned them to horrific neglect and emotional coldness. It doesn't, in the circumstances, take much to be returned back to this place. We are animals who are primed to sniff out in the present the slightest sign of the dangers of the past.

The tragedy of triggering is that it fails to notice the differences between then and now; between the awfulness we suffered long ago and the relative innocence of the modern moment. In so far as bad things do happen nowadays, triggering also fails to account for the way in which we are no longer children, and are therefore able to respond to the threats that do come our way with a lot more creativity, strength and calm than we possessed as 4- or 10-year-olds. Were things ever to get as bad as they once were, we have so many more options than we did – and therefore so many reasons to feel less agitated and vulnerable.

To be triggered is to lose our powers of discrimination. In the heat of the moment, we can no longer distinguish between A and B. So frightening is A that everything between it and Q is, at heart, another A. We can't tell that someone is not telling us that we are guilty, that the situation isn't evidence of doom, that we are not being mocked, that our colleague isn't attacking us, that we aren't being reprimanded unbearably, that we haven't been told we're an idiot or a monster. We can't distinguish between looking a bit tired and looking fundamentally unacceptable, between something they've done that got them sent to prison and something we've done that won't ever be noticed. So primed has our history made us to appalling scenarios, we have no ability not to refind them at every turn – especially when we are a little low or tired.

Though we might assume that we'd want to escape our triggers, we are also drawn to them through a compulsive sense of familiarity. Calm and confidence aren't our resting places; they don't feel normal

and are therefore worrying in their own way. We want our awful hunches confirmed. It can feel right to put ourselves in environments where people might be mocking, to look out for stories of disgrace or ruin or to befriend people who are constantly on the edge of undermining us. When our mood feels eerie and sad, we might go to the very website that triggers us or call up the person we know is going to alarm us.

The cure for triggering is love; love understood as a process of patiently holding someone and, like a kindly and soothing parent, helping them to discriminate between black and white, terror and calm, evil and goodness. The cure lies too in learning to work backwards from our current triggers to the dynamics that once created them. Rather than worrying yet more about the future, we should ask ourselves the simple question: What does my fear of what will happen tell me about what did happen? What scenario from my past is contained in my alarm at the future?

To overcome our triggers is to come to navigate the present with all the confidence and excited curiosity that should have been ours from the start. And maturity could be defined as: knowing what triggers us and why – and a commitment to dampening our first responses in the name of a patient exploration and understanding of the past.

### WHY PARENTS CAN BE NASTY TO THEIR OWN CHILDREN

One of the strangest and saddest phenomena of psychological life is that there are parents, too many parents, who end up – while sometimes only half realising it – bullying their own children.

The bullying may take many forms: from suggesting the child is ugly and stupid all the way to physically and sexually abusing them. It's quite literally one of the saddest things in the world.

Why do parents bully their children? In short, in order to try to feel better about themselves. Because they suffer intensely in the very same area in which they are bullying their child. If we, as former children, want to know what our parents were afraid of or haunted by, we only need to ask: in what areas did they bully me? What did they make me feel scared or inadequate about? Someone made them feel awful and they surmise – by twisted logic – that they will feel better through the process of making their own child feel very bad indeed. In a strange way, they don't mean it personally; the child is collateral damage to a misguided project of healing and attenuation of symptoms. It doesn't make any sense, of course, but it may actually work for the parent, for a time.

Let's imagine a parent who harbours a terrible fear of being stupid; somewhere in their own past, they were belittled and made to feel hugely inadequate. Now a child comes along, their own child, full of the normal hesitations and weaknesses of early infancy. Without really realising what they are up to, the parent grows inflamed and incensed by this child's apparent stupidity – and starts to mock and attack in another what they fear and hate in themselves. It makes them feel a bit better. The child becomes a repository of all that they fail to tolerate in themselves. They, the child, are the dumb one, so they, the parent, don't have to be; they, the child, are the stupid and ugly one, so they, the parent, don't have to be. The child is a cry baby, a weakling and a pathetic twig. And therefore the parent is liberated to live more easily within themselves. The bad is contained and localised; it can't be in them if it is all in little him or her. 'Don't be such a moron or a ninny. Stop being such a wimp,' the parent screams at the child, in the hope that no idiocy or weakness remains in them.

The same logic operates in the most appalling form of bullying that is child abuse. Let's imagine that the parent is carrying a sense

of being corrupted, ill and soiled. Perhaps they too were abused – long ago. By abusing a child of their own who is as pure, hopeful and innocent as they once were, they hope to rid themselves of their poison, to inject it into some other being in order to live more freely and lightly. The child will go around thinking themselves bad and wrong, so that the parent no longer has to. The child will be doomed and perhaps the parent will get a new lease of life.

It can take bullied children a very long time to realise they have been bullied. They don't, after all, grow up thinking that someone else has actually made them feel stupid or made them feel ugly or made them feel soiled – let alone their own parent, whom they depend on and admire and long to be loved by. They simply think they are stupid, ugly and soiled. There is no call for an explanation or a cause.

Yet if we are those now grown-up bullied children, we don't need to wonder too much more about what might have happened to us. We simply need to take stock of how we feel about ourselves and guess that the terrible judgements and sensations that we have about ourselves did not arise spontaneously. They are the outcome of events – physical behaviours as well as words and atmospheres that we were subjected to. The feelings we harbour of ourselves are legacies of real occurrences in the world. Someone, who isn't necessarily owning up to it, made us feel a certain way – and that is why we are now in such pain.

Typically, those who have been bullied don't look backwards. Their illnesses point them relentlessly to the present and the future. The bullied anticipate terrible things happening to them that echo events that once happened to them, but that they don't remember in any way. They are causeless paranoiacs, self-haters and worriers. Catastrophe is never far away. A person feels they are ugly because, two decades ago, a mother made them feel as much. A person feels

they have done something very wrong because, even further back, someone did something very wrong to them. The fear contains the imprint of unconscious history.

We overcome our bullying when we learn to discriminate: between what actually belongs to us and what was placed in us; between who we are and what we've been told we are; between how our caregivers like to present themselves and what they have actually done. Our triggers and apprehensions lie along the faultlines of our early traumas; they can guide us back to what we once suffered through, when we are ready to explore it.

It's sad enough that children are bullied by their parents; it's even sadder that a legacy of this is that children can't realise what happened to them. And instead, typically, they fall victim to the same tricks played out by substitute figures in their later lives: partners, colleagues, even the media.

We're on our way to overcoming bullying when we can say, at last, I am not ugly, I was made to feel unacceptable. I haven't done anything wrong, something wrong was done to me. And in general: I am not awful – something awful happened to me.

### WHAT IS A GOOD PARENT?

This book introduces us to so many inadequate parents that we might find ourselves eventually asking a large and naive-sounding question: what is a good parent?

Firstly and most importantly, a competent parent is someone who can feel inordinately pleased that their child has come into the world – and who never ceases to remind themselves or their offspring of the fact, in direct and indirect ways, at small and large moments, pretty much every day. There is no risk of spoiling anyone in this

way: spoilt people are those who were denied love, not those who were regularly bathed in its calming waters. It's no easy matter to make it through adult life – and boundless early enthusiasm fortifies us for the backbreaking journey ahead. So long as we have tasted love for long enough at the start, we stand never to lose hope entirely in the tumultuous periods that follow. Love will be our finest protector against despair.

Secondly, the good parent is attuned to their child; they listen – very closely indeed – to what the small person is trying to say. This means getting down on their knees and calmly paying attention to messages that may sometimes sound extremely weird or frustrating. Maybe the child is saying that they are very sad, even though it's their birthday and the parent has gone to enormous trouble with the presents. Maybe they are saying that they are angry with the teacher, even if education is in principle very important and the school was difficult to get into. Maybe they are explaining that they are fed up with Granny, though of course she means well and she's our mother too. Children are filled with complicated emotions that may have no place in the average adult's assessment of what is 'normal', let alone convenient. Good parents suspend judgement and check their certainties. There is no danger of creating an entitled brat by doing so. People who cause a fuss don't generally do so because they have been listened to a lot; they start screaming (and later taking drugs and robbing shops) because the messages of their smaller, younger selves were never heard.

A good parent is, furthermore, not so fragile that they constantly need to be obeyed. They can take being sometimes called a fool; they have long ago lost their pride. They're sufficiently on top of the unfairness of life not to mind being someone on whom a child, especially a teenage one, occasionally offloads their disappointments at the misery of everything. They don't need to instil

terror; they have the self-confidence to be ignored or overlooked brusquely when a child's development requires it.

A good parent isn't envious of their children. They are strong enough to allow them to have a better life than they did.

They aren't sadists: they never derive relief from making a child miserable. They don't feel any cleverer themselves by telling the child that they're an idiot, or more in control by monitoring the child's every move. They don't want to pass on their sadness and regret. They don't think it's a good idea to make someone very unhappy because someone else made them miserable long ago.

They are sufficiently on top of their issues to be able to warn their children about them. They make it easy for the child to work out what the family madness is – and to move on from it. They don't insist on their normality and then set their child the challenge of determining where they've been lied to. They don't inject their poison into anyone: their jealousy, terror, ambition or disappointment remain matters for them alone.

They don't need attention from their own children. They have enough of an audience elsewhere. They don't demand admiration – and certainly not gratitude.

They know how to be calm and even boring. They absorb the child's excitements and terrors without adding to them. They show up day after day and act with reliable dullness; of course they have drama going on beneath the surface, it's just that no child wants to think of their parent as overly complicated or three-dimensional. The good parent doesn't mind being, in a benign sense, a caricature.

The good parent knows how to play; their imaginations are free: the doll can be a princess, the sofa could be a ship and dinner might be pushed back by half an hour without peril. They're solid enough

inside not to need to impose rigidity on the world. Sometimes, they can allow themselves to be very silly.

They know about boundaries. The game was hilarious for a long time, but now it's the moment to wind down, to put the paints away, to get back to work or to go up to bed. The good parent doesn't mind being hated for a time in the name of honouring reality.

Around the good parent, the child is, at the same time, allowed to utter 'no' about certain matters, and has sufficient autonomy to disagree. The child may not always have a say, but they should invariably have a voice.

The good parent is tender: of course teddy's lost eye doesn't matter in the broad run of things, but the child's world is small, and minor things loom large in it. Good parents therefore have the patience to respond to the child's minor crises and delights from a sure sense that maturity will emerge through precisely targeted indulgence.

### HOW TO LOOK AT THE IMAGES HERE

Not all stories here have the power to touch us in equal measure. Some may leave us rather cold; others, however, will summon a more visceral response. It pays to notice the difference and to use it as a springboard to self-exploration. As a generalisation, the stories that feel powerful must, in some way, be catching on an aspect of our own lives; the specifics might be different (class, age, region), yet a part of us is being summoned. We could also say: we feel intensely around art what we have not, perhaps, been able to feel too intensely in the course of our lives.

We might keep a notepad with us as we flip through the pages and, every time we sense a nascent intense emotion, ask ourselves the following:

*– What aspect of this story is touching me?*
*– What is sad, regrettable, awful or beautiful?*
*– Where do this story and my story intersect?*
*– What might I know intellectually but not allow myself to feel*
  *sufficiently or sufficiently often in my own story?*

We might, for example, come to an intellectual understanding of our early years. We might know that we are timid around figures of authority because our father was remote and distant, or that we have trouble trusting partners because of what happened around our mother. Assembling such insights might already have been the work of many years and, having reached it, we could reasonably expect that our problems would abate.

But the mind's knots are, sadly, not so simple to unpick. An intellectual understanding of the past, though not wrong, still often fails to release us from blocks and miseries. For this, we have to edge our way towards a far more close-up, detailed, sensory appreciation of where we have come from and what we have suffered. We need to strive for what we can call an emotional understanding of the past – as opposed to a top-down, abbreviated intellectual one.

We will have to re-experience at what we might call an artistic level a whole set of scenes from our early life in which our problems were formed. We will need to let our imaginations wander back to certain moments that have been too unbearable to keep alive in a three-dimensional form in our active memories (the mind liking, unless actively prompted, to reduce most of what we've been through to headings rather than the full story, a document that it shelves in remote locations of the inner library). We need not only to know that we had a difficult relationship with our father, but also to relive the sorrow as if it were happening to us today. We don't just need to

know there were problems with our mother: we need to experience them in their fullness of sorrow, in order to be freed of them. We need the emotions that works of art carry, not just headlines.

Psychotherapy knows that thinking is hugely important – but on its own, within the therapeutic process itself, it is not the key to fixing our psychological problems. It insists on a crucial difference between broadly recognising that we were shy as a child and re-experiencing, in its full intensity, what it was like to feel cowed, ignored and in constant danger of being rebuffed or mocked; the difference between knowing, in an abstract way, that our mother wasn't much focused on us when we were little and reconnecting with the desolate feelings we had when we tried to share certain of our needs with her.

Therapy builds on the idea of a return to live feelings. It's only when we're properly in touch with feelings that we can correct them with the help of our more mature faculties – and thereby address the real troubles of our adult lives.

Oddly (and interestingly) this means intellectual people can have a particularly tricky time in therapy. They get interested in the ideas. But they don't so easily recreate and exhibit the pains and distresses of their earlier, less sophisticated selves, though it's actually these parts of who we all are that need to be encountered, listened to and – perhaps for the first time – comforted and reassured.

We need, to get fully better, to go back in time, perhaps every week or so for a few years, and deeply relive what it was like to be us at 5 and 9 and 15 – and allow ourselves to weep and be terrified and furious in accordance with the reality of the situation. And it is on the basis of this kind of hard-won emotional knowledge, not its more painless intellectual kind, that we may one day, with a fair wind, discover a measure of relief for some of the troubles within.

In this spirit, we might consider the series of 'Questions for self-exploration' dotted throughout the book, on pages 62, 92, 120, 144, 159 and 175.

## USING THE BOOK WITH OTHERS

It is hard to understand anyone properly without knowing some of what went on both in their family of origin and in their present family. One way to use the book is to lend it to a friend – perhaps someone we are still relatively unacquainted with – and then for both of us to pick out four stories that particularly touch us. These can then become an occasion for discussion:

– *Why did we each pick out the stories we did?*
– *What do our choices tell us about our own families?*
– *How would we like to be photographed?*

## YOU AS THE REAL SUBJECT OF THIS BOOK

Ultimately, we are the most significant subjects of this book. Looking at others gives us the chance to understand ourselves more clearly. But in order for this to happen, we need to ask our shy minds questions at regular intervals:

– *If a photographer came to visit you to discuss the theme of families, what would you most want to talk to them about?*
– *Where would you want to be photographed – and how?*
– *What might you be tempted to tell the photographer, but ultimately might not be able to share?*
– *Who in this book would you most want to be friends with?*

*What can you imagine talking to them about?*
*Why have you chosen them?*
– *If you had magical powers, what problems faced by
families – your own and others – would you most urgently
want to solve?*
– *What do you want to tell the world about families?*
– *How do you imagine readers would respond to your
own story?*
– *Complete the sentence: my childhood has taught me that…*
– *I would ideally want to tell my father…*
– *I would ideally want to tell my mother…*
– *I would ideally want to tell my child/children…*

### A HOPE FOR THE FUTURE

We might in all modesty say that most of us have no clue how to lead, or submit ourselves to, family life.

This is a task at least as complicated as managing a company or learning the violin, and yet one for which we lack any systematic form of instruction. We are thrown into possibly the most consequential area of human activity without any semblance of training or caution.

Collectively, humans have been messing up family life for millennia, or – more accurately – 300 generations or so. In that time, extraordinary insights have been gained. But this has happened in highly scattered and diffuse ways. Towards the end of their lives, in their 92nd or (in the early days of the species) their 25th years, the oldest toothless grey-haired members of the tribe will have come to certain wise ideas about families: they will have realised the centrality of love, that it is no good shouting or getting violent, that what is always key is patience, that kindness is what makes children strong.

But these insights tend to come far too late. The damage is done and they are neither properly collected nor arranged in a curriculum that could stand a chance of shielding children from similar problems in succeeding decades.

The neglect of education has been as foolish as letting each new generation learn physics on their own: as if we were committed to throwing Euclid and Newton onto a bonfire every few years and hoping the kids would stumble on comparable ideas on their own.

Cascading, continuous problems have followed. We should note the marked lag between our technical ability – our enormous increase in knowledge around all scientific matters – and our emotional abilities, where we remain at the same level as the Picts or the Ancient Sumerians. We have wound-up, emotional infants equipped with supercomputers and nuclear warheads.

The hope is that, in time, we will learn to get a little more cautious and better organised. We will realise that no one should be allowed to embark on family life without undergoing instruction at least as thorough as that required to operate a car or, more optimistically, a sizeable passenger airliner. We need classrooms, simulators, examinations and textbooks here too.

The things that have hurt the lives of some of the people in the pages that follow aren't in any way sophisticated. They are often rookie errors. But we should never underestimate the power of rookie errors to destroy our species; it's a particular vanity to believe that what damages lives has to be *complicated*.

The book seeks in a minor way to try to contribute to a future in which our beginnings are no longer fraught nor broken. It longs for a time when more of us will have the emotionally coherent family lives that should be a universal birthright.

# THE CHILD

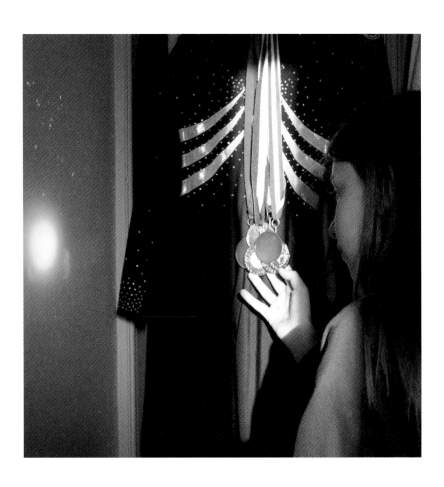

# EDEN

Sometimes I feel like I am trying my best, but it is just not good enough. I am constantly being told that I am not trying hard enough, when in reality no one knows the goals I have in my mind. Sometimes I just want to stop caring about what everyone else thinks. But I constantly worry about being judged.

I love my family a lot, and I know they love me, but it is hard sometimes. I feel like no one listens to me and I just want to say how I really feel. I love my brother and I wish he knew that. I do not mean to get mad or to be rude, and I wish I was a better sister. I also wish I could be a better daughter and a better friend.

I get shouted at to get ready for school and then by teachers at school and sometimes friends. Teachers say things like that I am underachieving. Then sometimes my coach tells me I need to try harder. But some days my legs really hurt. Sometimes it all feels too much. People never really know what you are going through. Everyone has their struggles and people just need to be a lot more open and caring.

I promise you I do try.

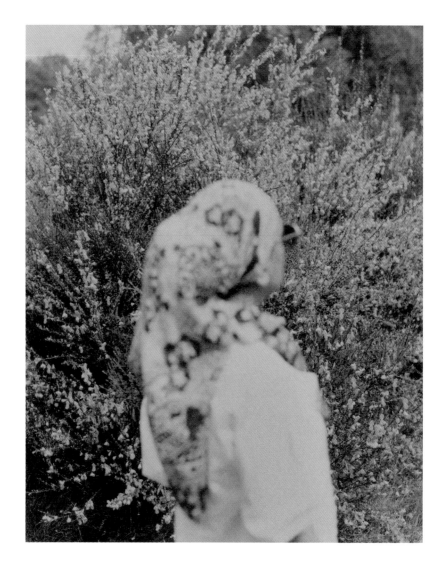

# SHELL

My mum and dad were first cousins. They got married. Then when they came to this country, he became very abusive towards her. From a young age, 2 or 3, my mum would say that when my dad went to hit her, I'd try to get in the way, to protect her. I'm very protective of people even now.

I think I was about 15 when my mum finally got a divorce. It was a stigma within our culture to get a divorce, no matter how abusive your husband was. Very quickly her family pushed her to marry somebody else. My stepdad was not much better.

Mum had her first stroke when she was 34, which is very young. My stepdad would try to emotionally manipulate her, and I'd get defensive, so we'd have physical altercations as well. Eventually my stepdad kicked me out. I used to go back there, clean, give her a bath, and then leave again. My caring duties started from a young age. When I turned 16, my stepdad left, and I was her sole carer.

I was a troubled teenager. No one stopped to think, why am I troubled? I don't think any adult in my life ever did.

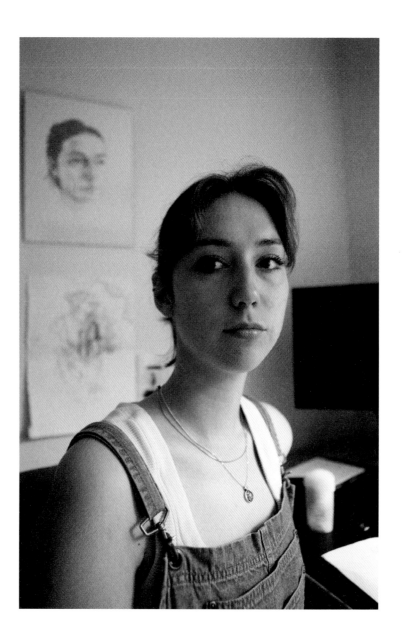

# MARIA

When I first found out about Mum's diagnosis, I couldn't really comprehend what was happening. It wasn't until a week after her mastectomy that I actually found out the details of her cancer. It was such a shock – my mum, who's never ill or vulnerable or weak, was suddenly so ill. I was (and maybe still am) in denial about the whole thing. Of course, she's going to be okay, she's MUM and she's ALWAYS OKAY.

Living away from home means that I don't see her in that illness often; I'm not caring for her or taking her to the hospital. Seeing her struggle to drink water, sleep through the night, or even stand up from the side effects sent home how frail she was becoming and that she was really very ill. That's when I started to understand that my parents are ageing and there's no going back from there. It is heartbreaking.

I often feel so guilty for not spending more time at home with Mum, helping to care for her as she recovers, but work means I can't be away too long. I sometimes feel that I get in the way when I'm home – my family has a smooth system without me. It's also selfish, but coming back more than one weekend every few weeks would be too difficult. Leaving allows me to compartmentalise and to live in the current moment.

## AMY

We feel like it's getting quite out of hand now. We used to be able to restrict what time and how much time he has on the screens. We'd say maybe a maximum of an hour a day. Then it spiralled and he would be playing it for three, four, five hours a day. We've realised that we can't go back from that now; he's just got used to that amount of access to screens. Although he does do other activities and we have days out together, and he can be distracted from it if we're out of the house, as soon as we get back, it's 'Can I go on the screen?'.

I worry about the isolation. Everyone's doing their own thing in their own room and not interacting with me or their dad, not really talking to each other. If I want to get a decent conversation out of them at dinner time, I basically have to ask about their games. There's some other topics that we can talk about, but I'm being dragged into it because it's the only thing that they have any real passion about.

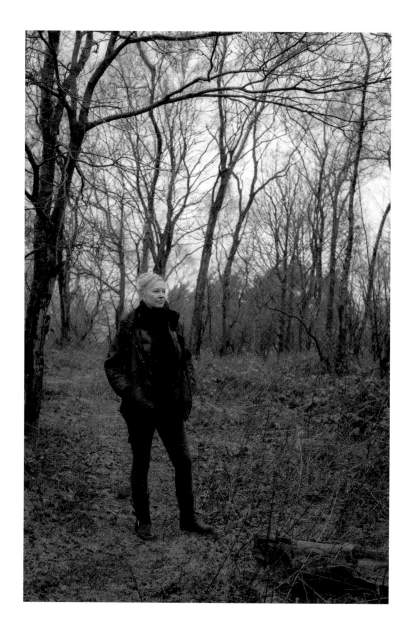

# KATHY

I've always felt on my own, I had to be independent, responsible for myself. I absolutely hated boarding school, it's criminal. You might as well have no education, you know? Why would you do that to a child? What is the point of getting a fine set of GCSEs if you're going to spend the rest of your life so insecure and unconfident that you can't do anything with them anyway?

I used to seek out groups of people all the time. Growing up I felt like I was in a family unit for such a short time. I don't feel I was nurtured in any way. So, I've definitely gone overboard with my own family on that.

There's no greater joy than being a parent; it's a gift. I find it strange that you wouldn't want to be the closest person to your children. I love to spend time with them. I find it physically traumatic not to see them. Even now, knowing they're in the house makes me feel grounded. There's not much I don't tell my children.

It's been hard having that empty nest syndrome, feeling them leading their own lives. But they are great individuals who I am really proud of. Hopefully I've provided something better than my own childhood.

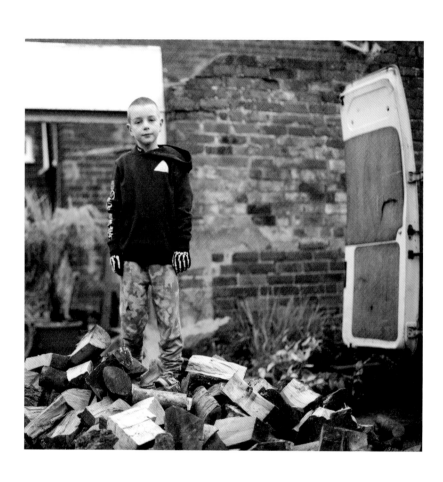

# CONRAD

On school mornings, my parents can be a bit bossy and grumpy. But they normally get me to school on time. Maybe adults are grumpy because they are tired and have a lot going on. Dad goes to meetings all the time. I sometimes miss Dad when he is not home. Daddy is a woodworker; he builds stuff for people, like kitchens and cabinets, all of that stuff. I like seeing Dad when he is nice. I help him to train because he has a belly. We go to the basketball courts and have loads of fun. Sometimes we play on the Xbox, sometimes we go to town together, sometimes we go to the cinema.

I feel sad when I hear my mummy and daddy arguing. It's a bit tiring. I don't worry if they will stay together because I know that they love each other. They always say that they love each other, and they really do. No matter what arguments they have, they will never break up.

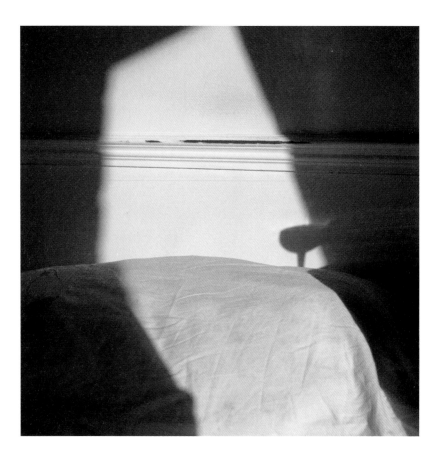

## POLLY

Having been a member of AA for many years, I have come to understand that the core root of my addiction stems from early childhood experiences. For me, that means a childhood of being insecure, unstable and full of uncertainty. I remember living in a fantasy world: 'if only I had different parents my life would be…', etc. When I first got drunk at 13, I felt happy, and the fear melted away. I'd found the medicine to blot out my incessant insecurities. From that point on I chased that experience.

Over the years my obsession with drink overcame me. Through my 20s it was fun but with consequences – shame, embarrassment, injuries. Then, in my 30s, I had my kids thinking that would sort me out, but it only consolidated a deeper dependency. I continued to drink daily. The denial became stronger the more I justified my need to drink over my responsibilities. The consequences were a level of self-loathing that became a vicious cycle – 'I'm a bad mother', 'I'm weak-willed'…

In my early 40s, I sought out AA meetings in my area. Over the course of many meetings, hearing other people's experiences and identifying with them, the desire to drink left me. The first year was choppy, but each day I haven't drunk, waking up with no shame and becoming present to my life, has given me hope and strength.

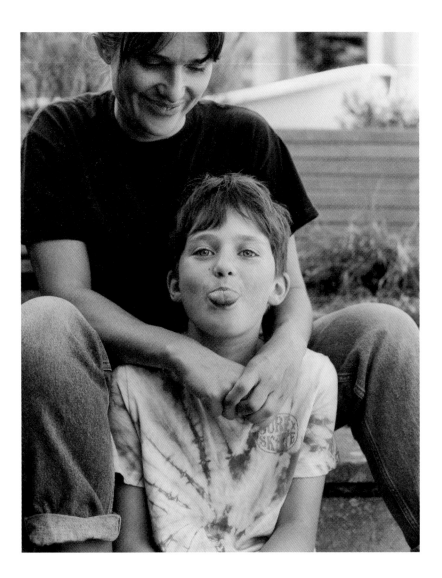

# ALEX

*(with C)*

C's dad and I split up when he was 4. From early on, C was always more like a tomboy. And then at 4-ish, he started to say, 'I am a boy'. When he started school, that's when it went up a notch. All of his school friends were quick to say: 'you are a boy'. It took us a little while as a family; we did they/them pronouns for a while, it was like a bridge, I suppose, while he explored his gender. Then we switched into he/him pronouns and socially transitioned when he was 7.

C is 9 now; it's not a million miles away from puberty. I try to strike a balance between informing him about what's to come and not triggering body dysmorphia. We changed schools recently and I was talking to C about whether he wanted to go to this school without people knowing or with them knowing. He decided he didn't want secrecy, which I think is quite a toxic feeling for a kid to have. The school was brilliant. They did this thing where they simply said: 'C's starting, he was born a girl, now he identifies as a boy. Does anyone have any questions?' They got them to write down questions and they were all things like, 'What colour hair does he have?', 'What's his favourite food?' None of them were the kinds of questions that an adult would ever ask.

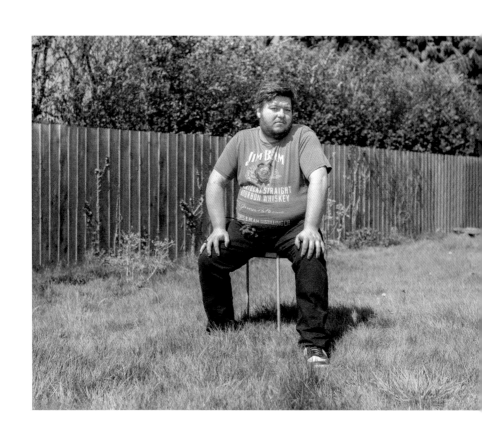

# MICHAEL

I don't know much about my early life. My birth parents were only teenagers and they stayed together for about six months after I was born. My mother then met someone else. I have one half-brother and two half-sisters.

I was about 3 when I was taken away from my mother and put into foster care. There were some foster carers that were okay, and some that were not very good. One of the places was with a lovely lady, but I didn't stay there very long. I had a lot of anger issues at school; I remember hitting one of the other kids with a plastic swing ball bat just because he said he liked Digimon more than Pokémon. I was adopted when I was 8.

I don't know what my dreams are for the future; I'd like to start my own business but sometimes I just want to do nothing. If I am feeling depressed, I will find something to watch on YouTube so that I can cut off completely from any emotions when I feel they're getting too strong. It's difficult for me to have positive emotions. I have no clue how to control happiness as I didn't experience any when I was younger. I am, however, very good in a crisis.

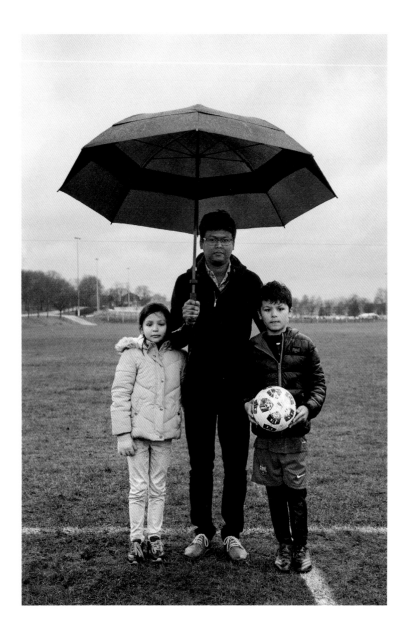

# ISMAIL

## *(with Yasin and Roqaiya)*

I was born in Bangladesh, with five brothers and sisters. I'm the youngest in my family. All parents wanted their child to be an engineer or doctor or businessman. But I like art. And my parents never forbade me to do that. My sister used to take me everywhere in Bangladesh to take part in art competitions. I was determined. I went to a prestigious art school in Bangladesh and then I came to London in 2004 to finish studying. I love art because this is something that is coming from my feelings, from my inside. When I finished, I went to Edinburgh for a summer holiday and there I met a Polish woman and she fell in love with me.

We really love the environment being here in the UK. But what I had in Bangladesh, all the heritage, family affections, family love, my children are missing that. They don't have uncles, aunts, cousins, no one in the UK except me and my wife. My daughter speaks Polish but doesn't speak Bengali at all; my son is keen to learn. My mum especially really wants to talk to them. My children only met their Bangladesh family twice, but they don't know much about them because of the communication gap. I have to translate everything, but it's not the same. There's this little corner in my soft heart that always belongs to Bangladesh, even though I'm happy here.

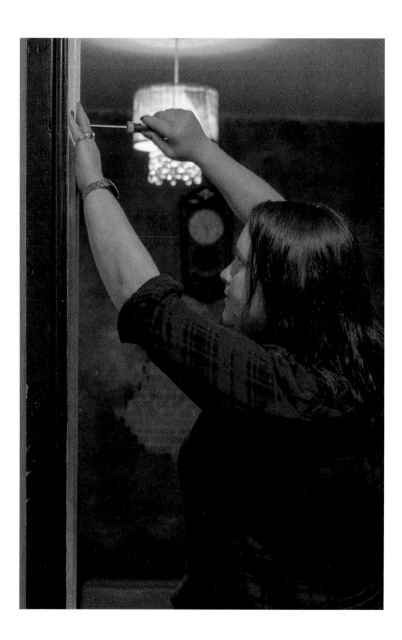

# VIK

I have four children, one of whom has autism and pathological demand avoidance, which means he cannot follow a demand, and everything can be perceived as a demand. Even as a baby he was different. As a toddler he started banging his head in frustration, and it became clear that he had no fear of danger and thought only of how he could get what he wanted.

Gradually, he started to hurt himself, destroy things and eventually hurt others. He started taking things off other people too. My husband and I went to every parenting class available over the years. I always believed all our children should be treated equally – but without thinking about it, our lives began to centre around my son.

Anything could set him off. Asking him to put on his shoes could result in a huge meltdown, with violence and swear words. It might take us up to an hour just to leave the house or we wouldn't make it out at all. As he got bigger it became more dangerous, resulting in me getting hurt and ending up in hospital. Once, I hadn't predicted his response accurately and wound up with a dislocated arm.

Our whole lives focus on safety and emergency contingencies for when de-escalation techniques do not work. All our other children know our safety plan, leaving the room and taking anything breakable or harmful, from cups to heavy objects. They know where the panic phone is for the police and how to use it. I am often having to fix up the house after his episodes.

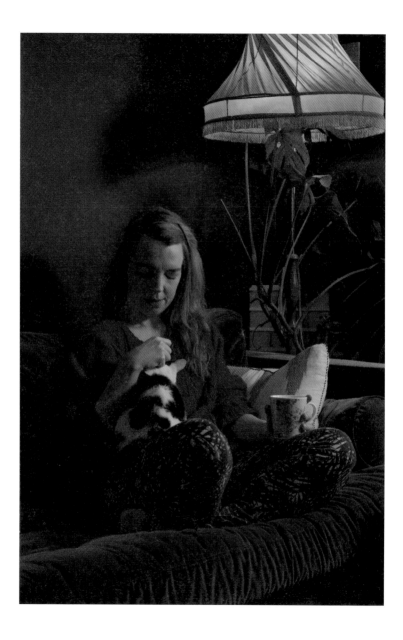

## LAURA

I was the oldest of three, a good academic child. From an early age there were a lot of expectations on me at home. I did well at school, went to university, then straight into a career in teaching. I felt like I was ticking all the boxes: husband, house, career… the next thing on the list was children. That's when things became more complicated.

It was difficult for me to get pregnant. I had polycystic ovary syndrome and had to take some very strong fertility drugs. It was all very traumatic and took a long time. When the kids eventually came, I felt like I had to get everything right and the pressures piled up. Eventually I had a massive breakdown. It was an absolute car crash. Things went wrong with my marriage, we started divorce proceedings, and I had trouble at work too.

I've learned over the last few years to let my expectations go and it's made life so much easier. In a way, the whole breakdown was a good thing because, almost for the first time, my mum and dad started looking after me. It wasn't their fault that they hadn't before – I'd never let them. I'd always been so independent and stubborn, and just hadn't allowed them to help me with anything. And yet, I actually really needed the help. It's just lovely now.

## QUESTIONS FOR SELF-EXPLORATION

What don't members of your family understand?

Where do you still need to heal?

How do you respond to the risks involved in loving
someone who might wander off, not be interested –
or one day die?

(If applicable) What disappoints you most
about your children?

In what ways – if any –
did your parents not love you enough?

What did you worry about in relation to family when
you were a child? What particular anxieties did you
have then?

What unfortunate aspect of your life now can be
attributed to something from your past?

What makes you most joyful about family?

How has a parent failed you?

How is your psychology a response to that of
your parents?

What did you learn about what it is to 'succeed'
from your family of origin? How do you feel about
these ideals?

How did you 'succeed' in the way your caregivers
wanted you to? And how did you depart from their
ideas of success?

What coping strategies – positive and negative –
have you adopted in relation to the pressures of family?

When I want to cry about family it's because…

# MOTHER

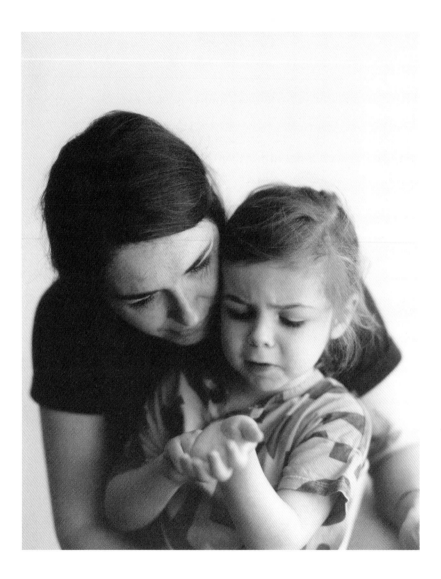

# AIMÉE
*(with Kit)*

I have to check myself with my children; I can disengage from them because I love them so much, and yet I feel I can't love them too much because of how unbearable it would be if something happened to them. It's such a sad thing. Even with my siblings, whom I adore, sometimes I don't put in the effort. It's easier.

I had a wonderful childhood until the day, it was in November, when Mum told us she wasn't very well at all. By February, she gathered us all in her room. 'I'm sorry, I have gall bladder cancer, it's been missed and now it's spread so much, they can't help me', she told us. People die of cancer all the time, but the way it all happened was gut wrenching; she was only 50. I can't unsee certain things that happened, which she wouldn't ever have wanted us to see. It was truly a horrible death. I don't think any of us have ever done anything to deserve something like that.

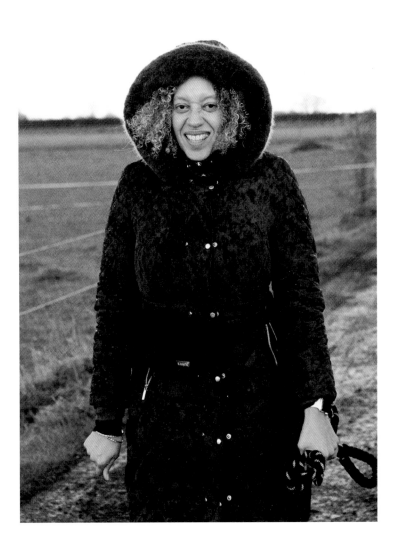

# LOUISE

I was 19 when I had my eldest child. My second I was 26, third 29 and my youngest 32. I was excited for my first, but I was also nervous about what people would think and what Mum and Dad would say about me being pregnant at 18 – I didn't want them to be disappointed because they wanted me to do well in my career.

At first it was difficult because of the stigma attached to being a teenage mum. I was the only one out of my friends to have a child that young. It was hard having people look down at me. I didn't like people's attitudes because I actually felt old enough to have a child and I enjoyed being a mum. I think I was very natural at it.

I didn't want to be a single parent either because of the stigma attached to that too. I wanted things to work out. My mum and dad were always together when I was growing up and I wanted to give my children the same. I split up from my partner when my second child was three months old. It was difficult thinking about starting another relationship after that, but I did, and unfortunately that one didn't work out either. It wasn't what I set out to do. If things had worked out with the partners, I would have preferred that, but neither relationship was going to last. I know it has impacted all of the children in different ways, but I did my best to raise them in a caring and loving home, and with the support of my mum, dad and close friends.

# MARIAN

My two teenage daughters stopped talking to me when my relationship with my partner came to an end. I send them encouraging messages, but they don't reply. It's like I'm dead to them.

I just don't know a way through. The elder one got into a good university – amazing – but I worry about her mental health. The youngest will only see me with a counsellor, which we did, and she said only to contact her if I was ill. They both lay down a lot of boundaries. The eldest asks me not to contact her at all.

I've been trying to do what they want, but sometimes I just can't help myself. I say: 'Look, I want you to know that I love you' or 'Do you not want to try to meet up so we can start again?'

I didn't get everything right, but I know I love my kids, I'd do anything for them. Sometimes I was upset about the state of my relationship, but it seems a torture too far not speaking.

I've got a lot of their stuff in boxes. I don't know when I'm ever going to see them again, so it makes sense for their dad to have them. But he's saying he doesn't have any space in his three-bedroom house.

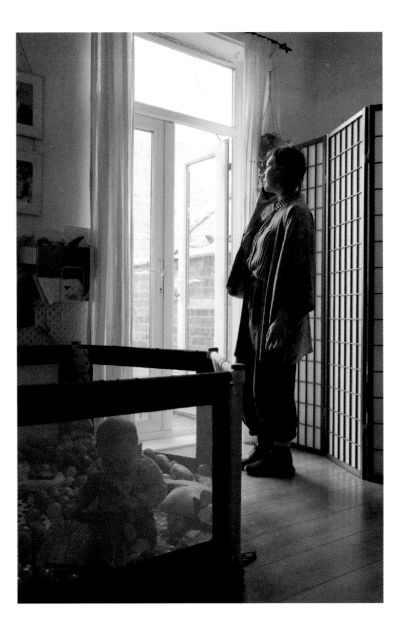

## NATALIE
*(with Austin)*

He's just turned nine months, my second child. He is very sweet, really cute, but it hasn't been so fun for me, really. I'm very tired, very emotional.

I loved my first maternity leave. I was really looking forward to this one as well, but it just hasn't been the same. I hadn't factored in that looking after two children is different to looking after one. The sleep deprivation is even worse the second time around as there are no opportunities to recover. I was expecting it to be easier too as I thought I'd learnt everything with my first, but I now realise they're all different, their personalities are different, and they want to be cared for in different ways.

The thought of going back to work is causing me a lot of anxiety. I've always been a worrier, all my life, anxiety has always been there. But I suppose the focus has shifted onto the children now and it's quite intense when I'm worrying about them. I'm highly strung – that's why I've been crying a number of times today.

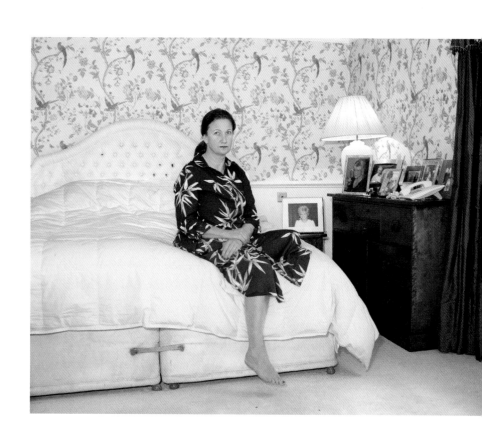

# LOUISE

My mum was always on a 600-calorie diet. I remember when I was about 8 or 9, she once fainted on me. She desperately wanted to be slim. When she died it made me so sad as in her wardrobe were all these designer clothes in size 10 or 12, which she never wore but had bought hoping to wear one day.

I don't know if she felt she had to fit in with the other school mums. My younger sister went to private school. I am not sure if she felt ashamed; we certainly weren't one of the wealthy families; we holidayed in Cornwall.

In the 70s, it was all about the glamour of women: the *Dallas* and *Dynasty* types and 'page 3' models. For a while, I wanted to be that person with the red lipstick, the red nails, etc. I'd obviously seen my mum dieting and counting calories, and I thought if I watched what I ate, I could be one of Robert Palmer's girls.

I felt so sorry and empty looking at my mother when she died and thinking that she never fulfilled her dreams and never wore the clothes she liked. She could have bought size 16 dresses and felt amazing in them. My goal is to get to the day I die and for my kids to smile and say, 'Our mother had the best life; she didn't care what she looked like'.

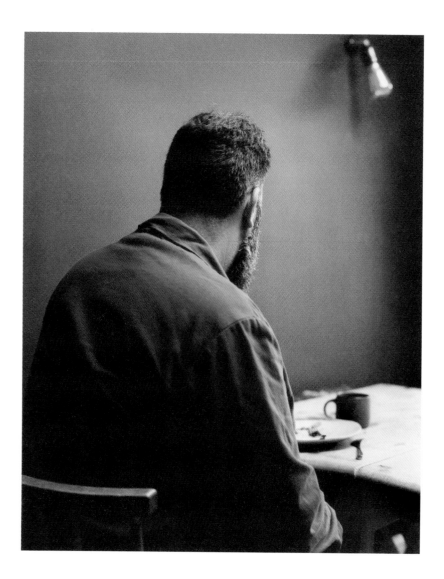

## SIMON

Weight has been a huge thing for me. Firstly, because I had my mum overfeeding me. Then we spent a lot of time with my Nan, on my dad's side, and she did that as well. She'd pick us up from school and take us for a Burger King – before taking us home for dinner.

From childhood, my dad would be shouting and stomping. I think it all came from overcompensating – my mum buying a present or food rather than what you really need, which is emotional support and help through the difficult things. That wasn't there. It was all, 'Let's go buy some cake'. When I have seen my mum more recently, she's tried to be like that with my son. I'll push back and be like: 'Just because he said he wants a giant bottle of Capri Sun, which he never gets at home, that doesn't mean you should buy it for him'.

I still haven't managed to get to a better space with eating and I know it. It's ingrained stress. I understand it, I've read enough. I know eating isn't going to give me this feeling that I'm trying to get. But, even knowing that, it's an addiction. And that's especially hard as a parent because you're aware you're trying to build good habits. Everything can be very difficult.

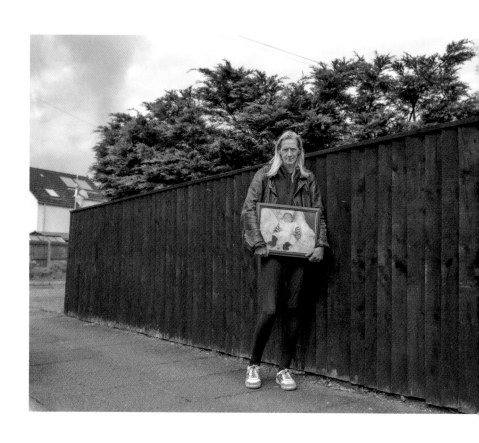

# LORRAINE

My son was three-and-a-half-months old when he died from cot death. I found him in his bed and I tried to revive him. He was rushed off to hospital and then we had social services and the police coming into the house; they thought I'd killed him. They removed all the children. The whole thing tore the family apart as no-one knew what to believe.

My son contacted me as a grown-up and when we saw each other I broke down and we just cried and cried and cried. All I wanted to do was wrap him up and take him home, but he's got a new family and is settled with his girlfriend. I've just said to him: 'I'm here if you need me.' We have a lot of contact now and we talk regularly.

My oldest daughter I have seen but she has said she wants no part of my life. She has opted for her adopted parents. And my youngest daughter, I haven't seen her since she went into care when she was a year old.

I have to deal with it all 24/7. I find my gardening helps.

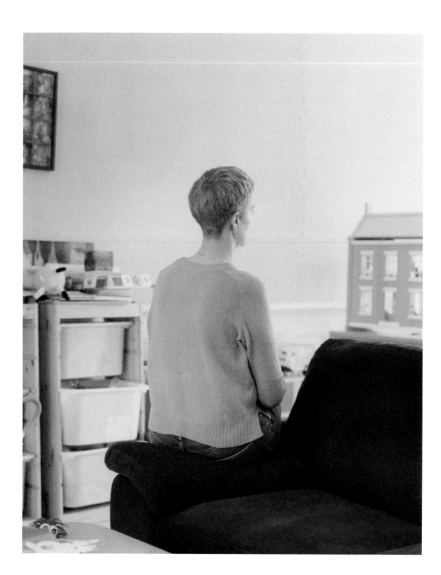

## KATE

I was 30 when I had my first child. Nobody really told me how difficult it might be, nobody warned me that she might come early and how horrible the recovery from birth might be. My husband went back out to work pretty much as if nothing had ever happened. I thought, I don't remember signing up for this. I don't think I'm a natural mother. Even things like playing games I find really difficult. And kids' playgrounds drive me insane. I did always want kids, and of course I adore them, but I wanted them in a very naive way.

I've put a lot of my career ambitions on the backburner. Or maybe buried them entirely, I don't know. The things I once thought I would achieve are not going to be possible now. At least if I want to be the kind of parent that I want to be – and not just farm them out to somebody else.

I do consider us to be a really fortunate family. It's just not how I imagined my life as a parent would be.

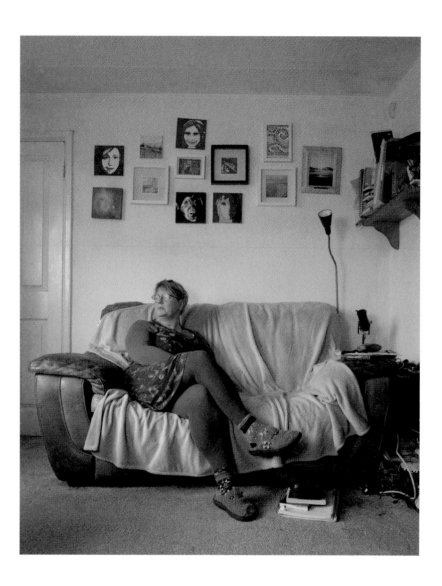

# CHRISTINE

I've got three daughters – my eldest is 22 and then twins who are 18 and leave for university this summer. After 20-plus years all together, it'll just be me and the dog from autumn, which will be quite a change!

Our family life has always worked around this room and the sofa. We'd have lovely evenings all squashed up watching television together. This room was just full of toys, a tip! The twins were like bear cubs, rolling around. I'd have to pretend a horse was going by to get them to stop. They still sit down for a hug and kind of just dump their problems like they always have… but now suddenly there's this full-grown adult sitting on you!

I got home the other evening and the house was empty. But as usual they'd done a really funny thing: one of them had opened all the kitchen cupboards just to be cheeky. We have quite a jokey family life.

I've always tried to be the safety net with all the chaos that goes on. Living at home is coming to an end, but being a parent doesn't end. I get texts like, 'Can you lend me some money?' or 'I've got this ache, am I dying?' You always question if you're doing the right thing, particularly when it's just you. But they've all independently come to me and said, 'Some of our friends' parents are nuts, we're really glad we've got you'. That is lovely. They've given me affirmation that I've done an okay job.

# JANET

My mother made our clothes and knitted all of our jumpers, hats, gloves and socks. She was a skilled seamstress, and we were always well turned out. In many ways she did her best for us.

But though she tried, there was something missing at the heart of her motherhood, and it took me until adulthood to understand what it was. She never showed us physical or emotional affection. Never held us, cuddled us, stroked our hair, told us she loved us or was proud of us. As a child, you are not aware of these things. You grow up thinking this is normal. When I was 6, I wrote little notes, which I would leave on her pillow: 'Mummy, I love you so much. Do you love me?' In the morning I would wait for her to say something, anything. She never did unless I prompted her: 'Did you find my note?' Sometimes silence, sometimes just 'yes' or mostly 'I love you all just the same'. All without warmth, affirmation or pleasure. I think I learned how to hide my sadness. Yet, the more she withheld affection, the more I tried to please her, working hard at school, picking bunches of wildflowers, trying to be good and help in the house.

It wasn't until I was an adult when my husband said to me, 'You do realise that your mother is a cold person?' It was a lightbulb moment and in a peculiar way a relief. After she died, I came across her personal diaries. In them, she spoke of the notes I had written, 'Janet is such a loving, affectionate and sensitive little girl. I don't know why I feel unable to respond to her'.

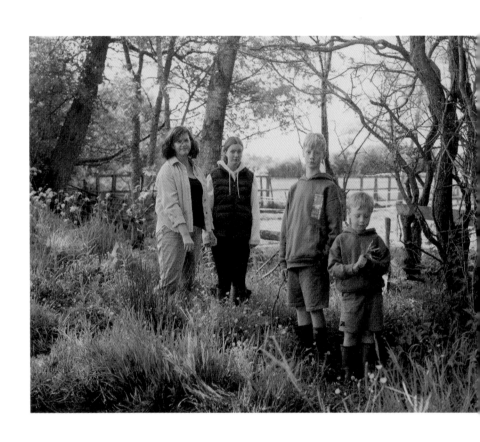

## ELIZABETH
*(with Lydia, William and Theo)*

Somebody called us the James Bond family, which makes us sound far more interesting than we are, but I don't ever want to stop my children from doing anything. I was an adult before I really felt brave enough to do some things. My mother was very overprotective, she worried about everything. Her dad was very ill with malaria after the war and ended his own life when she was just 19, so she's had a lot to deal with in life.

My daughter doesn't want to go to university. She wants to join the Royal Air Force as a weapons system operator – sitting in the back of a plane and potentially being in combat. We are immensely proud of her for choosing her own path. Initially, my mum did not deal well with that news, but she's mellowing with age and realising that everyone needs to live their own life. I was desperate to join the army at 18, but my mother didn't want me to, I think mostly because of her dad. I waited until I was a little older to pursue that particular passion.

All of my children were on skis from when they were tiny. We've got ponies and they've fallen off them plenty of times. As soon as they could reach the pedals, they were driving. We push the kids to do things that build their confidence.

I bought my mum a card a year ago and I felt terrible afterwards. It was that quote: 'Therapy is full of people who are there because of all the people that won't go to therapy'. She did not take it well at the time. We laugh about it now.

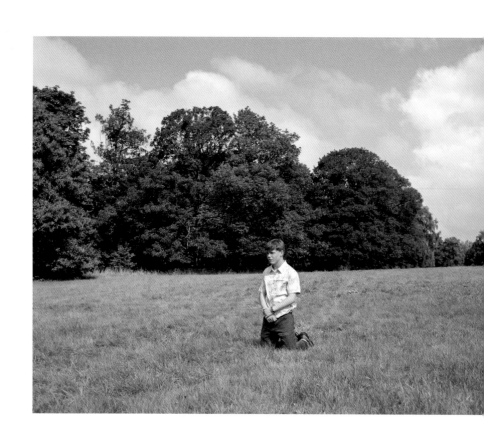

## CHRIS

My mum's drinking first started when I was around 6. I used to hate it. I remember seeing my mum wandering the streets in her dressing gown and wondering what the fuck were my friends going to think. With time, I got to understand it more. It is a choice, of course it's a choice. At the end of the day, you've got to take responsibility for what you do, but I've got more sympathy for her having that first drink.

I honestly think it has made me a better person. I gave some money to a homeless guy and one of my mates said: 'He's just going to get a bag with that.' I said: 'Well, tonight, if that's the difference between him getting to sleep or him sitting up all night shivering, we'll have that.'

She was in hospital a few times before she died. She'd started medication and went to rehab for a bit once. It only took a change in my dad's tone on the phone for me to know what had happened. I knew what it was, but I didn't want to believe it. I cried and I hugged him – and then that was that. That was the end of the whole situation.

I love her, I love her as much as I ever have, that's never going to change. It's been four years now and it hasn't got easier to deal with. I don't know if grief ever ends; how could it? When I dream, which isn't often, most of the time it is in the form of some miraculous resurrection where my mum is stood in a doorway. Those dreams are the closest I've been to feeling content since it happened.

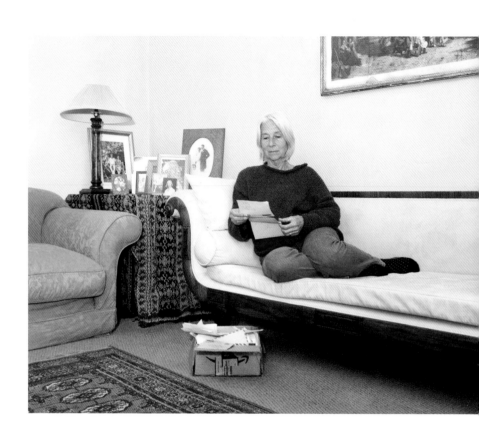

# INGRID

I was having a really difficult time as a teenager with my mum and my stepfather when one day my grandmother sat me down and said: 'There's something you should know: your mum isn't your mother. Your aunt is really your mother.' At that moment everything in my life turned upside down but somehow also fell into place.

My birth mother had met my father by answering an advert in a yachting magazine for a crewing position. They started writing and he visited her in London from Holland. I am the product of one week of passion. She didn't know he was married, and she wrote to him telling him she was pregnant. He didn't want to know as he didn't believe I was his. She was devastated.

In those days, there was a huge stigma attached to being an unmarried mother and having an illegitimate child – a 'bastard'. The family thought up an ideal solution: her brother and his wife would adopt the child. So, when I was six weeks old, I was handed over at the railway station. The truth of my birth was kept a secret until I was 16.

When I found out the truth, I wrote to my birth mother who was by then living in America, and she wrote back saying that she always knew she would hear from me one day, when the truth was out, and that the family had simply tried to protect me by not telling me. I eventually found my real father and fortunately built a good relationship with him. In time he wrote to my mother asking for her forgiveness. She replied to him: 'You know, it's fine, aren't we lucky that we got Ingrid out of this?' And so, 40 years on, they made peace with one another.

# QUESTIONS FOR SELF-EXPLORATION

What are you reacting against in the way you approach family life?

If you want or once wanted children, what is motivating you?

What secrets or unspoken things about sex have there been in your family?

How did your mother cause you problems?

(If applicable) In what ways are you a less than ideal parent?

What do you find harder than expected about family life?

What I would ideally want to tell my mother is…

In what areas of family life might you have 'perfectionist' impulses?

What sorrow do you carry around with you that your family doesn't grasp?

What would you want to warn the younger you
about becoming a mother?

What do you miss most when your family disperses?

What do you think your mother was reacting against
in the way she brought you up?

What happened in your mother's early life to account
for some of her difficulties?

What is most 'crazy' about my family is…

# FATHER

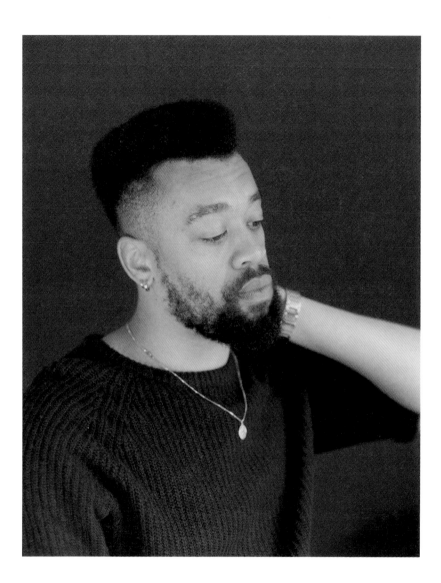

# CHRISTIAN

Growing up, I wasn't close to my dad. I just didn't take to him. Once I sussed out that he wasn't who I thought he was, I maintained my distance. I always saw him as very fake; he would behave in a certain way when we were out in public. For example, around his family or his friends, he'd come across like a great family man. But then in the home environment, he wouldn't interact with the family at all.

Because I haven't had a strong male role model, I ask myself so many questions: what is it to be a husband, a father, a partner? I doubt myself as a man. My friends have always mostly been women. In male relationships I feel weird; I don't know how to act. I'm not really interested in typical male behaviour. I've been in therapy on and off for a few years, just trying to unpack everything.

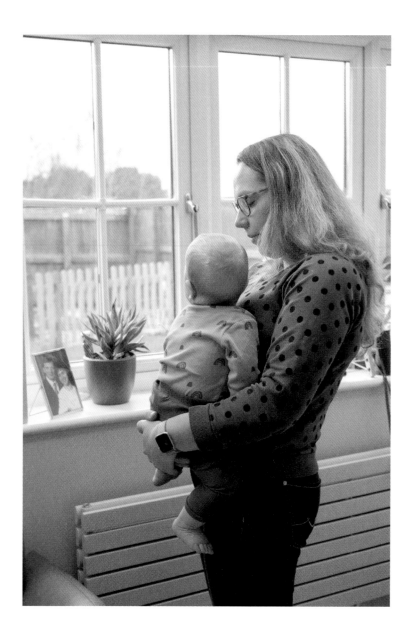

## DAGNIJA
*(with Tristan)*

I moved to the United Kingdom when I was 22, after graduating from medical school, to find a job. When I was 23 my mum suddenly passed away. It was an enormous blow. At one point I was very angry with life; I couldn't understand. It was also a big blow for my dad, but he felt the responsibility to put up a front and carry on supporting us.

My relationship with my dad became much closer. We would have 5 a.m. chats because of the time difference. He would not forget a single important event or birthday, no matter what. But, unfortunately, my dad became ill, and I lost him when I was 32. It's still a big void.

I'm an adult now, we've got two children. Dad was lucky enough to see my older daughter. We moved back to Latvia for a few months when he was really poorly, so he saw her a lot as a baby. I miss little things like the phone calls, the random chats. Sometimes, when something big happens, like passing my exam, I forget for a second and think, 'I need to ring Dad!'.

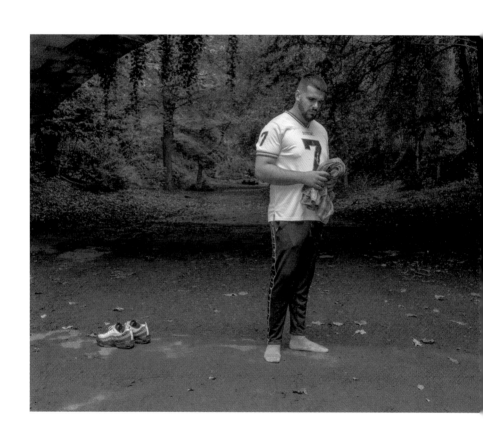

## KAVI

When I heard my dad died, I remember feeling like the heaviest weight in the world. You can't keep your head up, you can't put your shoulders back and hold yourself with any kind of posture, you just want to be on the floor, on the ground, and to scream. Loss means you can't recuperate things and for that reason you have guilt for things you didn't do or could have said and didn't.

I've now reached a point where I can openly analyse my dad and take him for what he was – a good person that didn't always act in that way because of outside factors that had influenced him. And because of the cards that the world dealt him and the way he handled them, this made him the way he was.

There are a lot of things that helped me get through his death. If there was anyone to thank it'd be my mom. I wear his rings pretty much every day. I've got a tattoo on my hand that you can see, that's always there. It's like a little message to everyone that I'm proud of him, I'm proud to be his son, despite all of the problems.

It's a nice thought when you consider that me and my sister are still here, we're still going strong, and we are going to keep growing – and that is all he ever wanted. He is at peace and us children are where we need to be. He could be very proud of us. What would've made him happy would be to have the first family he ever had back. He was so fixated on that.

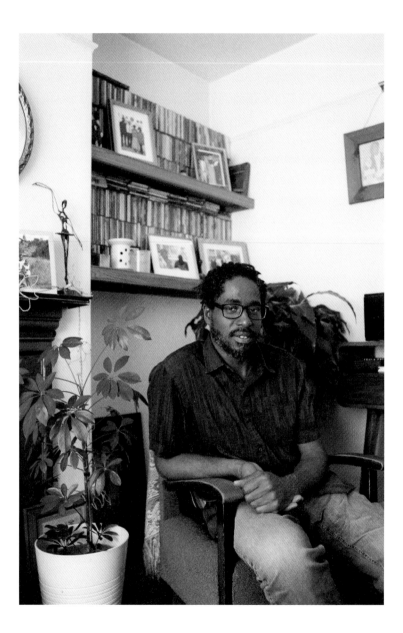

# SHAWN

You never feel ready to have a child, you never feel old enough. We were quite late, lots of our friends already had children. When you have a child, you realise that your own parents were probably making things up as they went along. There's no manual for it.

They say second children get dragged up, but first children get brought up. We were definitely stricter with the first, which is a bit sad, but I haven't seen any legacy of that. It was never over the top. I think overall we are both quite relaxed parents.

It's all about osmosis – to take things in rather than to drum things in. I always wanted my children to be around Black people, Black culture, Black history and for that to be normal for them, nothing extraordinary. I made sure they knew their family and went to Barbados where my parents are from. I'm a Rasta but they didn't grow up Rasta, they don't have dreadlocks or anything, but they've always been around me and my culture, and whether they identify with it or not, at least they know it's part of their upbringing and something they can relate to. They have their own path to go down; I didn't want to set that path for them but for them to know they can access it if they want to.

We've definitely tried to give them a comfortable life. I think it's important to be there for your children and to let them know they are safe and loved. It is important that they have stable people around. You lead by example and hope that they find their path to do what they want to do in life. They are their own people. What I always say to them is, you make me proud whatever you do; and I've had lots of proud moments.

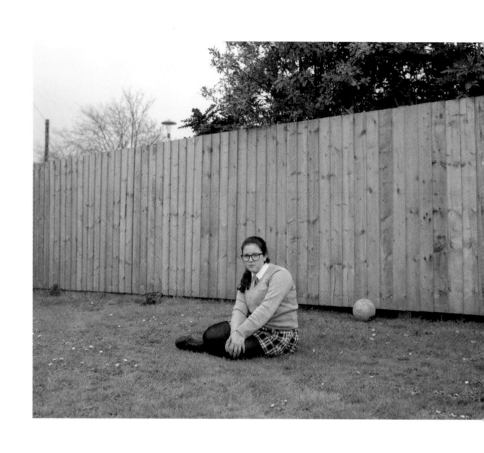

## TENESHA

I am 14 years old. I wasn't even born when my mother and father separated. I never see my father – I know who he is though. I don't really care that I don't see him now. I have been hurt and angry in the past that he hasn't come to find me.

My stepfather – I get on with him and then I don't. I can have massive arguments with the family and then I can say 'you're not my dad' and I'll walk upstairs. My mum tries to make it better. We will have a disagreement, or I am in a bad mood, and they know to leave me alone – but if it gets that bad, I will either call my nan up or I'll shout.

My sister and brother can be annoying. I don't really care that they have my stepfather as their father, and I don't. But sometimes when we argue – I'll say 'half-sister'.

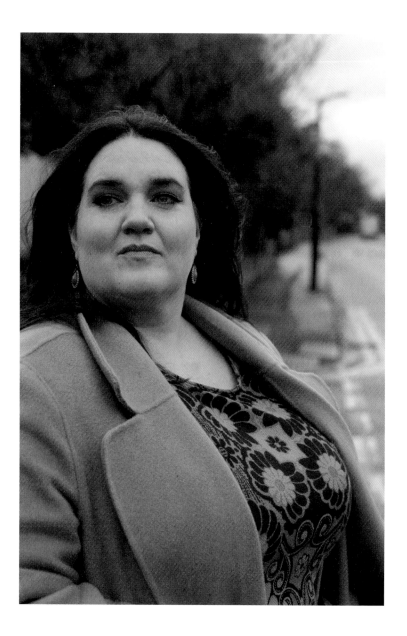

## ELEANOR

I was the second of two kids; my parents separated when I was 3. We maintained sporadic contact with my dad until the day before my 8th birthday, then he disappeared. He was quite a well-off man and so if I saw a fancy car, I would always think, 'this is it'. And if anything unfamiliar or strange happened, I would imagine, 'he's come back'. Even these days, every now and then, it pops into my head, 'what if?' At 40 years old, I think, 'what if I got home and he was just there?'

When I was a kid, it was very, 'I love you, daddy'. Then when I was a teenager and realised that he'd made a conscious decision to leave, it was very, 'Fuck you, I hate you'. And now as an adult, it's more a kind of 'very well, the past is the past, but we could still be friends'. I'm very conciliatory.

I know my brother was incredibly hurt, as hurt and upset as I was. The problem is that I exploded with it whereas he imploded with it. He became very insular and internalised. Neither of us want children – he never had that model and doesn't feel that he could do it well, and I feel it's just not something I could ever be interested in.

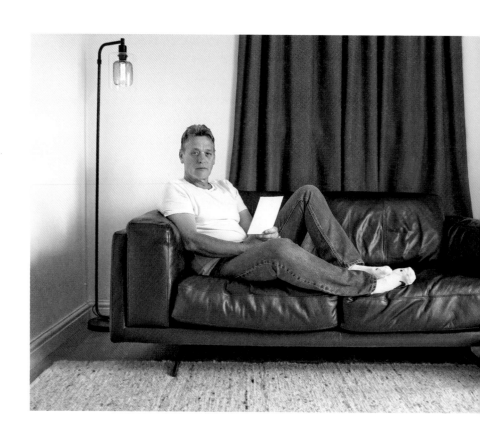

## ALAN

I was in a relationship with my partner for six years. We had a son together. We were going to get married, but two weeks before the date I decided not to. And when you do that to someone it hurts them, and that reflected in how she treated me after that.

We tried mediation at first, but it didn't work, so we had to go to court where I was granted a contact order with access at certain times. Initially I had to see my son at a supervised centre. After some months it progressed to me collecting him from home. I would text her as I wanted to know how he was doing. I ended up going to the magistrates' court for harassing her. I came out of court and thought I can't see my boy under these circumstances anymore.

My son is 12 now. I am hoping that when he is 14, he may want to contact me himself. I don't want to leave it till he is 18 as I am almost 60 and time is running out. Every day I think about him, not always what he is up to that day, more about the loss between us both.

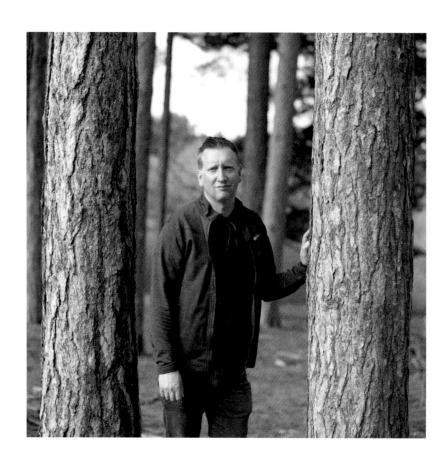

## JOE

I got made redundant two months before our first child was born. I always wanted to set up my own business and knew it would be something to do with joinery. The hard thing is knowing you've got a family coming and that you've got to provide a certain amount of money but also that you need to invest in a business and have cash flow to keep going.

The kids don't really understand what I do. Before work, I need to get them to school. It's an early start; that's just the way it is. It would be good to still have my youthful energy, but that's the way it is – until the kids can get themselves to school.

You can't lose confidence. Being self-employed is all about having massive obstacles and being able to overcome them. When you work for people, they just see you for a few hours, but you've had to prepare a lot the night before. If you take time off to enjoy your family, you get behind with the job. You have to be strong to do it all.

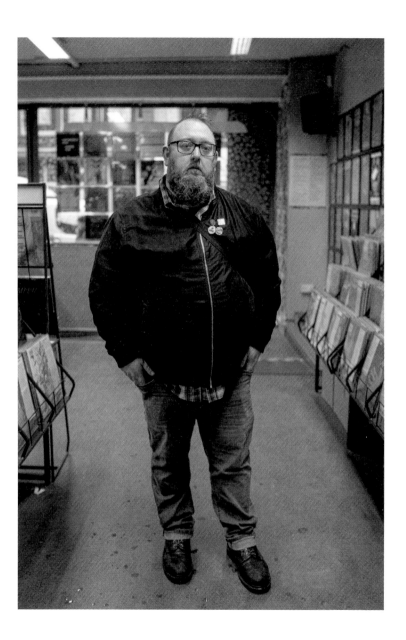

# JIM

My dad was a violent person. He was feared all over south Manchester. From my knowledge he was in prison at least six times. He never really told me what for and he only mentioned it a few years before his death when we – or rather I – made an attempt to patch things up. I wanted to let things go.

The earliest of the violence I can remember was being about 6 or 7 years old. I was having a tantrum about something after having been to the local library. It's kind of poignant because books, alongside music, have played such a big part in my life. He gave me such a beating, in public, around people. Then he just left and went to the pub. He used to like drinking.

In my early teens he used to punch me. He knocked me out a few times. It became normal. No one was going to stop him; my mother wasn't going to because he was so intimidating towards her as well – he used to beat the hell out of her. And we couldn't do anything about it because we were children. He was left to do whatever he wanted, really.

It was so traumatic, I had no idea what the effects were going to be; I don't think anyone does. The psychological, emotional and physical violence was never even thought about.

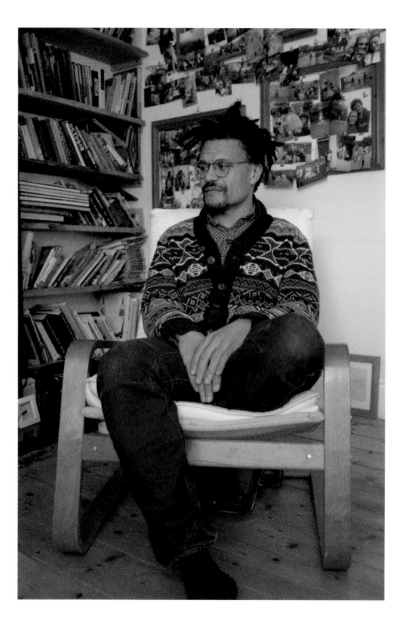

# JOSEPH

I grew up in the monocultural southwest, raised mainly by my white Cornish mum, with a Black dad who was a refugee from Uganda. They met at a poetry writing group in London where he was studying chemical science at university. He was a musician, she was a free spirit, and they ran away to the countryside to live an unconventional life.

When I was small, we (with my little sister) lived on a rundown council estate in Penzance. My dad didn't stay with us for long. He was off having adventures with his band and slowly succumbing to alcoholism. I think the drinking was a response to the pressures of being an out-of-place African character. He was loving and fun when I saw him, but hard to communicate with, especially when drunk.

Now I'm a father myself; my two children also have mixed racial identities, but we live in the north of England in a very mixed community. I've always wanted to be there for them in the way that my dad wasn't, to provide the stability and the connection that I never had, but also giving them some of the freedom and unconventionality that was great from my own childhood.

My issue is with my dad. That's what's brought on all my anxiety. As I've gotten older, the anxiety has got worse and worse. I think that with age you process what's been going on, whereas originally you just assumed that was life. I always felt this terrible worry about his anger. Especially if I did anything wrong. Nothing was ever good enough for him. At school, I was terrified of forgetting my books. I ended up with this huge bag and I'd carry everything, and I'd get blisters on my shoulders, all because I thought 'I can't get in trouble'. I still get really anxious; I'm terrified of making the wrong choice. I get quite anal in terms of my calendar: I really end up in a state if I don't know what I'm doing or if plans change. A therapist once said to me, 'you are in a permanent state of fight or flight'. Even with my husband, if he asks, 'what do you want to watch on the telly?', if I'm on a wobbly day that will make me nervous; what if I choose something he doesn't like?

After my dad had been horrible, he'd often go and buy you something – he felt guilty. It wouldn't be a bag of sweets; he would buy expensive Steiff bears. They had a white tag in their ear with a certificate and a box. I got so many Steiff bears over the years; they're all in boxes in the loft.

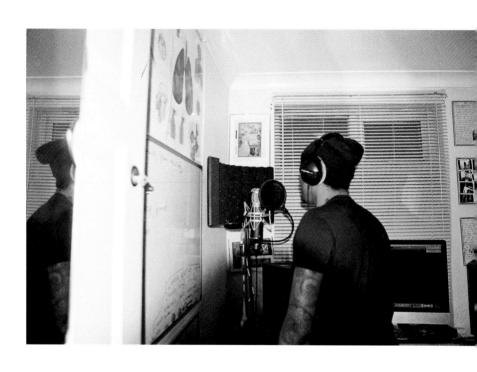

## KEVIN

When I was younger, I didn't think that a lot of my life was going to be travelling, on the road, singing, embracing different cities and getting a taste of different cultures – but also missing home.

Home has become different pieces of land, friends, chosen and born family. The person I miss most is my daughter. We currently live on different sides of the world, which has taught me a lot about love and patience as it was not of my choosing. Being present has been one of the biggest lessons – to enjoy her company, and not thinking about the future and having to part from her. In this process I have found great strength, acceptance and, in a weird way, more love.

When I watch the stars at night, I take solace thinking 'we are under the same skies' – this is a mantra we share. She knows I love her; and I know she loves me. My world is her and the sky is ours.

## QUESTIONS FOR SELF-EXPLORATION

How did your father cause you problems?

Which death in the family has affected –
or might affect – you most?

How do you cope with grief over a family member?

What advice would you give a new parent?

What I would ideally want to tell my father is…

What happened in your father's early life to account
for some of his difficulties?

(If applicable) What is your biggest regret as a parent?

What might outsiders not guess about you
and your family?

What experience, if any, do you have of violence
within family?

What can't be spoken about in your family?

What do you think your father was reacting against
in the way he brought you up?

What most terrified my family was…

What might be the true motto of your family?

# DIFFERENT ARRANGEMENTS

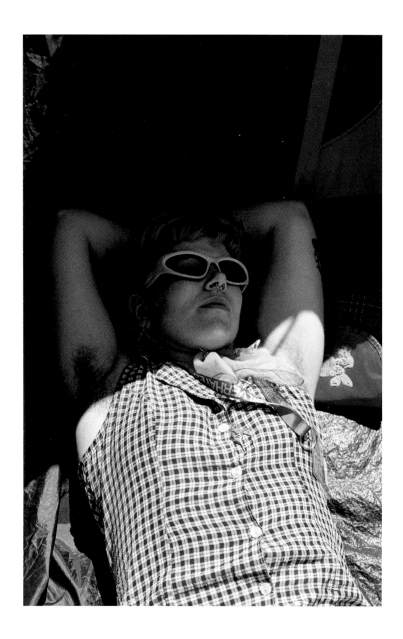

## KEZ

The other day, one of my best friends messaged me to say that their work had asked them to make a graph of an important member of their family, related or chosen, and this friend chose me. This made me emotional to feel that sense of value and belonging, and highlighted to me the importance of chosen family and the more expansive notion of what family can mean and look like in comparison to the nuclear ideals we're fed, especially as a queer person who grew up in a religious family.

Whilst I have a generally accepting family, I simply exist in different realms to their reality – and that applies not just to my gender identity and sexuality but also to the lifestyle choices and ways I've chosen to build my life. There's been a lot to work through in terms of growing up within a religion that condemns so much of who I am now and, on reflection, contributed to feelings of isolation, otherness and outsiderism while growing up. It wasn't until my early to mid-20s that I fully came into my queerness and since then I have been fortunate to find people who make me feel at home and provide a sense of belonging that pertains to family.

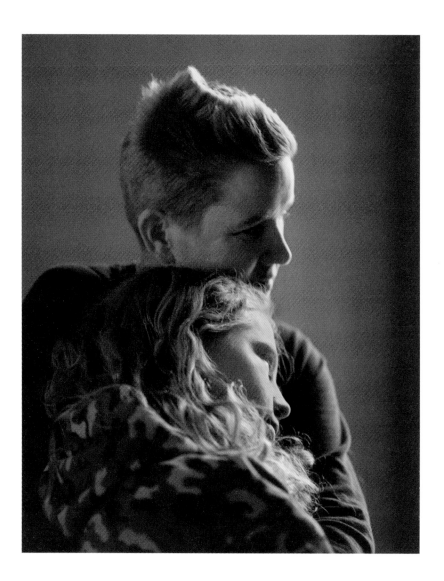

## SUE
### *(with Alison)*

My daughter is adopted; we've been together nearly nine years now. Being a single gay woman, you're not going to just suddenly get pregnant in the way that other people do. I got to the point of thinking: I'm going to have to go down some special avenue or it's just not going to happen. That in itself is scary.

She was just coming up for 3 when I adopted. The first day I went to see her, I was terrified. The foster parents asked me: 'Do you want me to record your first meeting?' And I replied, 'I don't even know what my name is any more.' Then she just suddenly appeared. She'd been in the kitchen and walked through and went: 'It's Mummy'. I can just about tell that story now without crying.

Her backstory was very chaotic: there was a family situation that didn't put her needs first. On her birthday, she's very excited, but I always think there's probably somebody somewhere for whom this day is pretty horrific.

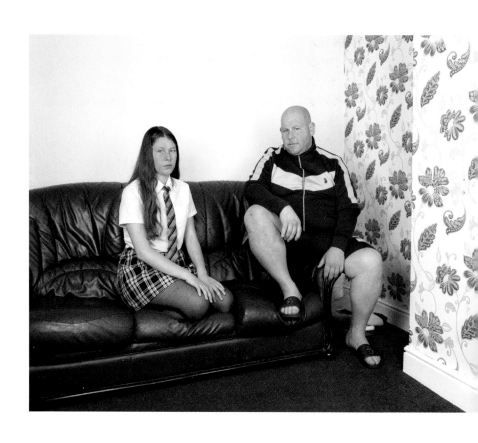

## BILLY
*(with Shaye)*

I was with my daughter's mother for about 10 years. My daughter used to live with her mum, but it wasn't working out between them, so she came to live with me. She's been with me for almost two years. I am trying to get our own place to live together, as I currently live with my parents, who are not so well, and her attitude can sometimes make the stress worse for them.

It has been difficult for me as I am dyslexic and the understanding and reading of all the paperwork for her makes me feel I don't know what to do or where I need to go, and I get so confused as I don't have the patience to resolve it. My sister helps fill the forms.

I adore my daughter, but the hardest part is trying to understand where her head is. She is very attached to me. I've never brought anyone home to introduce to her. However, things will change in due time: she knows that Daddy won't stay by himself forever and she has to learn to curb it and look at the situation from a different perspective.

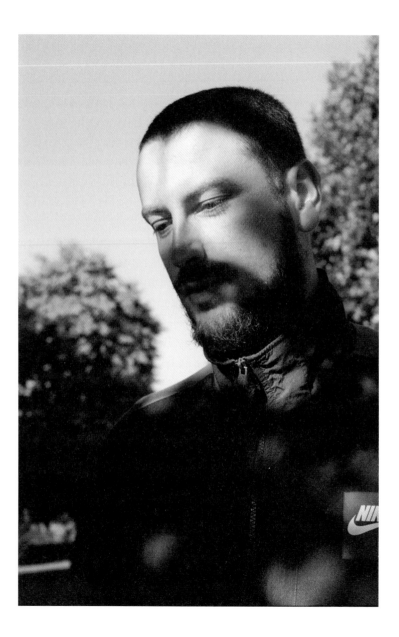

## GEORGE

A place to belong was what I needed growing up. Coming from a single-parent background, I was the man of the house at 13. My mum was often out at work and so I would be the chef cooking dinner and looking after my sister. I was lucky enough to have my grandparents' or friends' houses that I could stay at or go to after school. I think that's really vital, that sense of belonging, being part of a community, as opposed to just a household.

Coming from a single-parent background definitely made me feel isolated as not a lot of my friends at the time had separated parents, so they couldn't relate to what I was going through. My mum was working full-time, with no child support, and struggled with her mental health as a result. I witnessed her go through a lot of ups and downs but tried to be there for her as best I could when things got difficult. This ultimately brought us closer as a family because without my dad in the picture there was a greater sense of vulnerability.

Not having a father figure in the house does affect you, but it's only something that I've been able to reflect on as I've gotten older. It's weird because I was quite passive to it all at the time. I think that's why music is so important to me because it gave me some positive role models to follow and other people's stories to listen to – a chance to escape in a world where I couldn't always find peace.

Coming from a single-parent background has shaped the person I am today and has given me a different perspective on relationships. It has humbled me and has made me realise the importance of family and being there for one another.

# LUCY

I didn't consciously make a decision not to have kids. In my younger days, having kids struck me as being a tie and only something that was going to hold me down. In my late 20s and 30s I was all about work; relationships and having a family wasn't on my radar.

I definitely noticed a point in my life when other women my age very clearly had some force of nature that was driving them towards having kids. It often became this military manoeuvre – find a man, get married, have babies. I used to think, what is this? Is it a physical sensation, an invisible and inaudible alarm that goes off, and is there something wrong with me that I just don't feel it? I found it quite fascinating but not in a way that I felt I was missing out on anything. I never felt I owed anyone grandkids.

I'm 52 now, and I honestly feel more content than ever with not having children. I don't feel any sadness or regret if people ask if I have children. I feel very lucky to have a nephew, a niece and godkids, and I enjoy seeing them and all my friends' kids grow up into lovely and loving humans.

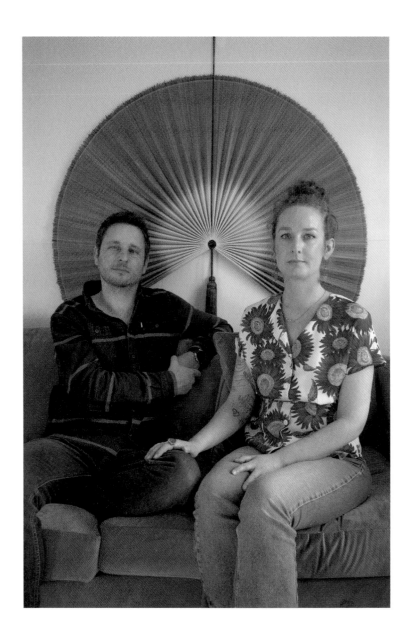

## KATE

### *(with Dave)*

My partner Dave has a son from a previous relationship. We've decided not to have any ourselves. I keep thinking that people who decide to have children often have no idea what's really involved. Perhaps they do it for the social reward. If you say, 'Oh, I'm thinking about having a baby', no one asks, 'Why's that?' Whereas if you say, 'I'm thinking about not having a baby', people start to ask a lot of questions. They interrogate you. They take it personally. People feel offended by the idea of you doing something they might choose not to do themselves. I don't have an opinion if someone else wants a kid or not, but it seems like the majority of people do have an opinion on my choices.

I might think, I'm not interested in having kids because I want to have a more stable financial future, I love my partner and I don't want anything to jeopardise that, I really enjoy my free time, I'm still trying to reparent myself, I like doing whatever I like and sleeping and having money and stuff like that. It makes other people very anxious about their own decisions. I've had women say to me, 'If I had any idea what it was like, I just wouldn't have done it' or 'I love my children, but they put me through hell.'

You can weigh up the pros and cons of this all day; it's not about reaching some definite answer, it's about your gut feeling. And my gut feeling is that it's probably not for us.

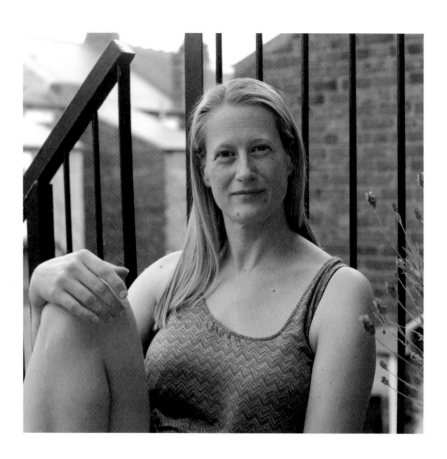

# KEELIE

Before having the girls, life was wild. We went out a lot. We had a big group of mutual friends. We partied hard. We travelled the world and had lots of adventures together. We loved each other and had fun.

We got together when I was 19; I'm 45 now. We both wanted kids, but having kids transforms you. No one tells you how hard it is. I couldn't be the person I was; I'd get not only a hangover but also a bad case of 'mum guilt'. As the years went by, I got into exercise, and I got to know different friends. But he didn't change. We had no help from family, so we were a tag team, never doing things together, and somewhere down the road we disconnected. We were together for 20 years – you either grow together or you grow apart.

It was a difficult decision to separate; however we knew it just wasn't working anymore. The day we told the children will be imprinted on my mind forever. It was awful. Kids are perceptive, they pick everything up, and very quickly they had a better, happier mum. I began to grow and thrive. Their dad and I co-parent very well – the kids come first. We still spend time as a family at Christmas and birthdays. We are thoughtful and respectful to each other and help each other out. The girls really appreciate that we get along; it makes it much easier for them.

## MARJOLAINE

Marriage is the hardest thing I've ever done. Each must allow the other to grow. Each must not grow too much or too fast – there must be enough light for everyone. Love is the thread that holds us together. But you learn there are lots of different kinds of 'love' and sometimes love takes a holiday, leaving you uncertain and confused.

Our wedding day – the start of married life – was a big event. Sometimes I wonder, would it be different if we had just chosen a quiet spot, let the wind and rain be part of the day, just a few friends and family. Would that have been more 'us'? Were we playing a part in the theatre of 'the wedding'?

Some years of marriage are glorious; some are so bad you feel like giving up – people don't warn you about those. I might have walked away in the darkest moments. I certainly thought about it and I'm sure my husband did too. When your spouse lets you down or you fail to live up to their expectations there is a deep despair and being married feels like fraud. But you have invested so much, shared so much. Things get better, time moves you to a new place. You decide to let go of grievances (well, you try) and then with each passing year somehow the marriage endures and on a good day you know yourself to be living in a negotiated peace, flourishing quietly.

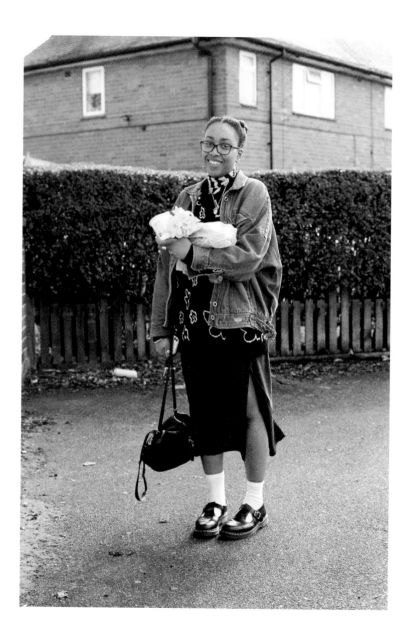

# JESSIE

I have good memories of when I was younger and I'd go and see my dad. We'd stay weekends and school holidays. Mom would take me and my brother into town after school on a Friday and we'd meet him and his partner at the time. We'd play loads of games, like hide-and-seek, and watch films and go swimming. They always had something planned for us to do. I used to see my cousins too; we'd have sleepovers. I remember when I was at primary school my dad would come to the school gates while I was on break and bring sweets for me and the other kids.

I don't know what happened, but I feel like my stepdad found my dad quite intimidating. I don't know if that's maybe because he wanted me to be his child or he wanted to have this happy family without my dad being involved. My stepdad didn't like it when I called my dad 'Dad' – I had to call him by his name. I remember one time I answered the phone to my dad. He wanted to speak to Mom, so I went to give her the phone and he heard me call him by his name – he was really upset with me. I hated doing that to my dad's face.

I've never felt like I needed to treat my half-siblings differently to how I treat my full sibling. I think maybe because we were all brought up together. Whenever I tell people about my siblings, I class them all the same. There could be more communication, but we've definitely got a good bond.

## LILY

I became a stepmother when I was 25. Unfortunately, it was not long before the boy's mother turned against me. You might have expected her to be grateful to someone who cared for her son. Wrong! In her eyes, I became this terrible person. Terrible for making cakes for his primary school fairs, terrible for buying him a winter coat, terrible for going to his parents' evenings, which she couldn't find time for. I loved another woman's little boy – and yet still his mother couldn't bring herself to feel in any way grateful.

The boy is grown up now. I'd be lying to say things were easy. In adolescence, he was especially difficult, refusing to do his homework or cooperate at home. He has a lot of dislike for women and no desire to be in a relationship. Sadly, he's refusing our offer of therapy. It's been a rollercoaster.

## QUESTIONS FOR SELF-EXPLORATION

In what ways does your experience of family differ from the standard story we are told about how things should go?

What might outsiders not guess about you and your family?

What are you grateful for in your family life?

(If applicable) What is hardest about growing up in/ raising a single-parent family? What is the best thing?

What do you want to repeat about your family growing up? And avoid?

How does your attitude towards having children reflect things about your own childhood?

People are drawn to each other as much for what is interestingly wrong with them as for what is right. What drew your parents together? (If applicable) What drew you to your partner?

What efforts do you make on behalf of your family that might not be appreciated as much as they might be?

About what things do members of your family spend a lot of time pretending?

# SIBLINGS

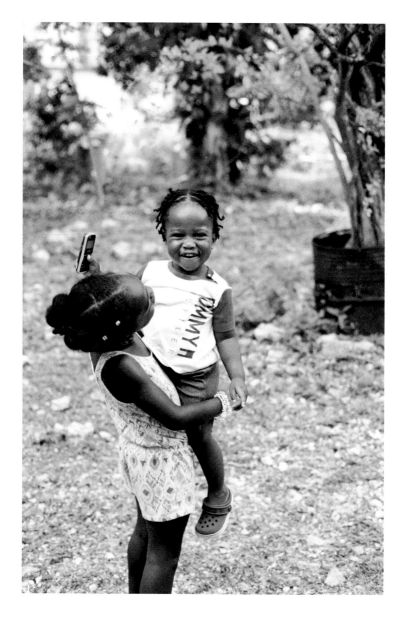

## KHALIAH
*(with Kajay)*

Being a big sister is when you take care of your brother or you take care of your sister and when your mum is busy you look after them, and when they're sitting in bed by themselves, you should go and sit there, and if they need to change, you change them. And I do not get paid when I do, but I don't mind because I love my brother.

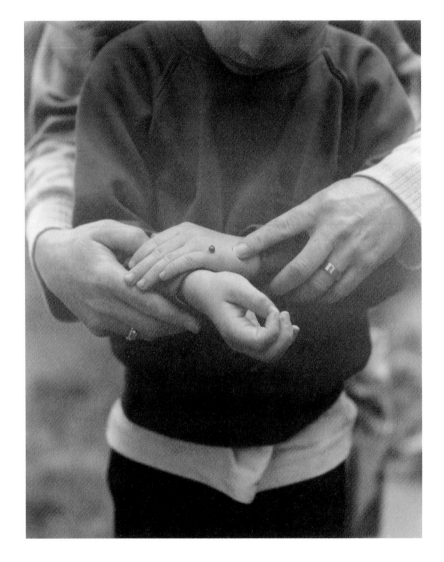

## TARA

### (with Arthur)

I was the real scapegoat in the family, as I think the eldest child is quite often. All sorts of weird stuff happened in terms of how Mum would divide and conquer us all. We'd been really close growing up, particularly me and my brother, very close, really similar. And then she picked him out as her favourite – the golden child. My sister, the youngest, was lost in the mix. I am most like my mum in many ways, but I was my mum's least favourite child.

My dad was very loving, very physically affectionate, but was also quite a weak character. My mum was the strong matriarch of the house. She controlled the money, controlled the business, made all the decisions about childcare, all of that kind of stuff. Whereas my dad was cooking and hoovering and giving us hugs. He was never going to stand up to her.

I remember reading this book called *Toxic Parents* and thinking, this is my life. All the roles that everybody in my family plays, these are the types of things that a sick family system does in order to sustain itself. I just thought, I'm not here for it anymore. After the estrangement, I sat in the bath every day for about a year and a half and cried visceral animal tears. It's like you can't be separated from the pack. That's how nature is, right? There are physiological things about belonging to the tribe and survival that you just can't escape.

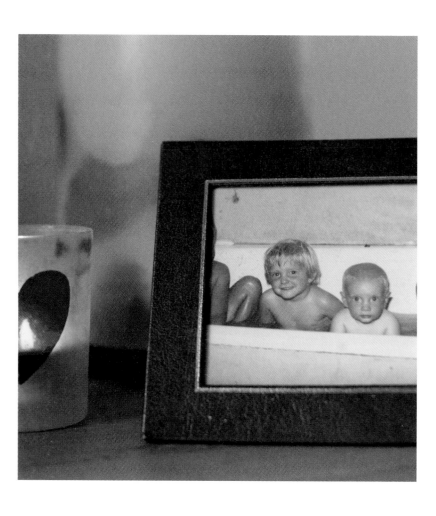

## RACHEL

My little brother was a lovely placid baby boy. He was easy to get along with. I could boss him around and he had a good nature. I can't recall him crying. He was very affectionate. There was quite a small age gap, so we were paired off. I was drawn to him because he wouldn't say mean things like the older ones.

Even through university, me and my younger brother stayed in close contact despite the lack of technology then. We would call each other, and he would remember my birthday. We would visit each other at university and go out with each other's friends. He was a thoughtful, kind brother. He lived in a total dive at university and when I went to visit, his friends told me he cleaned the house all weekend because his sister was coming. He let me sleep in his room and he slept on the sofa. He is a gentleman.

Later we were both off the rails for a while. We could relate to each other. Our lives have carried on in parallel in certain ways. Both getting married and having families. Now I wish we could see each other more. Physical distance makes it difficult, and we have busy careers. Yet when we see each other, it's always so easy.

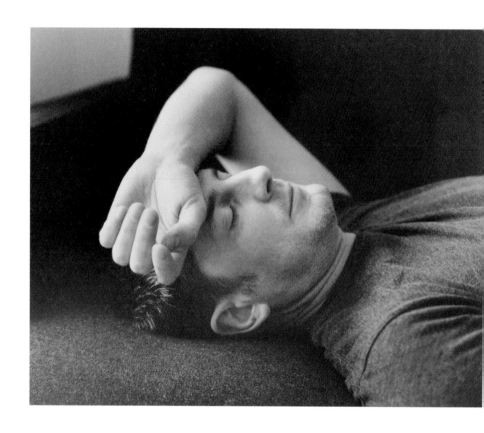

## DANIEL

Growing up, my relationship with my dad was awful. He had a really special bond with my sister, but not with me; and that difference really messed me up, it's hard to describe. My mum says that when I came along, she thought that he felt as if I'd taken her attention away from him. That's why he got so angry and critical. I became fearful of confrontation and very reclusive for many years. It was a sad existence.

Weirdly, I think it was in some ways worse for my sister. She felt so guilty about the wonderful relationship she had with my dad. I never felt animosity towards her, I just assumed that I must have been worse than her in some way, and that's why I got treated as I did.

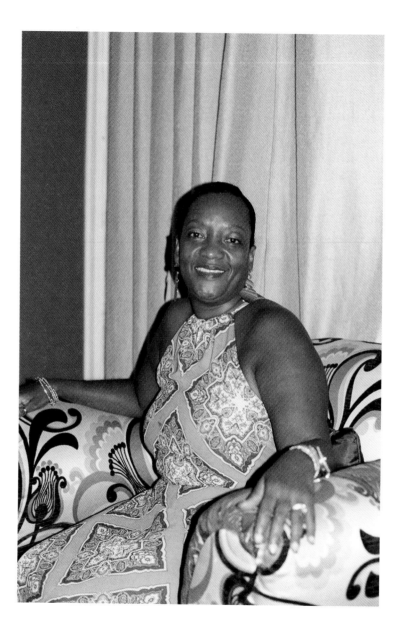

## CHERYL

I don't know that I've ever felt like an only child, although I am. It's primarily because I grew up with lots of cousins and it felt like they were my brothers and sisters. We were all so close. In fact, I ended up calling my mum 'Aunt' because that's what they all called her!

I think the part that actually made me feel like an only child was that my mum worked away from home. I was brought up by my grandma. Mum visited a lot and in summer I went to her. I wanted to be with Mum all the time; you know, everyone else's mum was around.

I promised my grandmother when I left that I would come back every year to visit her, and I did. I kept my promise until she died.

## QUESTIONS FOR SELF-EXPLORATION

What have you learnt from your siblings?

What don't 'they' warn you enough about family?

What do you want to repeat about your birth family?
And avoid?

How has your relationship with your siblings evolved?

What has your family left you feeling ashamed of?

How has the fear of rejection been handled in
your family?

(If applicable) How has being an only child
affected you?

# EXTENDED FAMILY

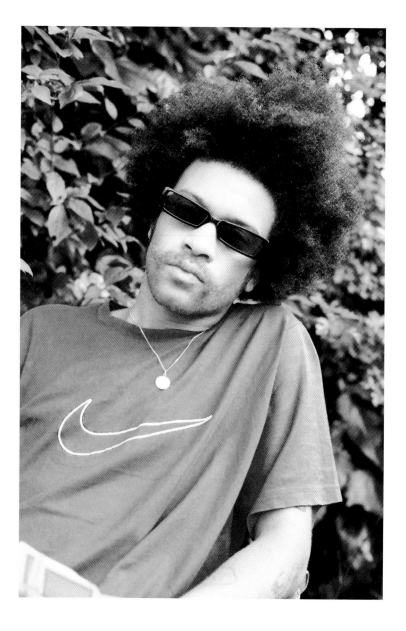

Do I see my people dem enough? You will have to ask them innit. Being in a different city to my family gave me an overwhelming sense of guilt, but now, being in the same city as the majority, the question rings even louder.

Three of my grandparents are battling some kind of illness. You think you should be doing more but can you do more? It is a perpetual struggle. Maybe they're just happy enough to know you exist.

I have always been close to my parents, siblings and grandparents, but it's difficult when you feel like you are missing out on life events, birthdays, even days that never held any real relevance – Sundays, Mondays…– but you want to know that you're able to strike a balance.

Maybe that's the problem with people pleasers. Maybe it's myself that needs pleasing before I can really please anyone else. Guilt is self-indulgent. Maybe I need to think less about myself and more about the people that are a part of who I am.

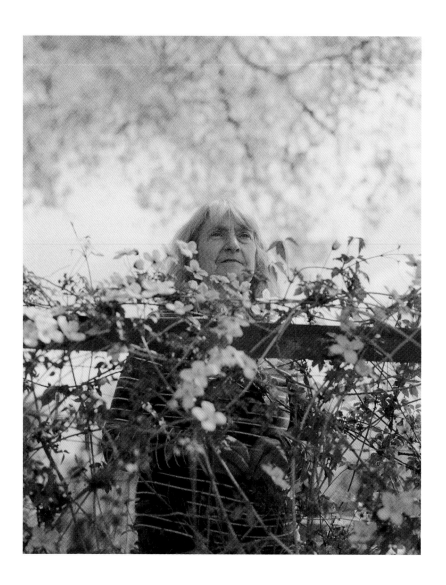

# JOAN

My first grandson was born in 2004, closely followed by a second in 2006. I loved being 'Nanny' and spent a lot of time with them. Then came the bombshell: my son and his partner were going to Australia, 'Just for two to three years' they said. I was so upset but I didn't want them to know. Before they left, they spent three wonderful months with me while they let out their house; I was doing the school runs and breakfasts and bath time. The boys were 6 and 8; I adored them. Then they went…

I must have cried every single night. I couldn't sleep, I didn't eat. Losing my son and grandsons was an enormous loss. It brought back memories of losing my mother. The two losses became one huge loss. I couldn't understand why my son would have chosen to go. I blamed myself and thought I must have been a terrible mother. That thought has stayed with me and I don't think it will ever go. My mum died; she didn't choose to leave me. My son had a choice and chose to leave.

I see friends' photos and hear about family get-togethers. That is something I will never have. We visited Australia once, but it's a long way away and very expensive too. Facetime is good, but it's not holding hands or stroking heads, it's ten minutes asking about the weather and 'what have you been doing?'.

I have so little contact with them. They have chosen to stay in Australia for good now and I am not part of their lives anymore. Loss feels the same – whether through death or emigration.

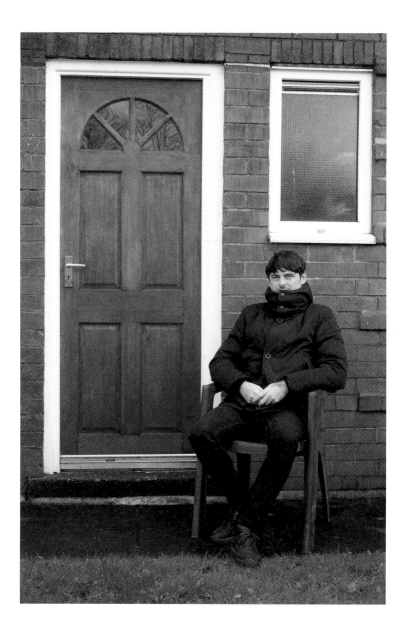

# LUKE

When we were children, we'd come here to see my grandparents regularly, three or four times a week. There was an old video shop at the end of the street, and we'd rent videos on a Friday night. That's something I'll always remember; just sitting there watching these old films with my grandparents. Or playing in the back garden. I've got so many good memories.

As I grew up, I found myself doing other things, spending more time with friends, and we lost touch. When you're in your teens, you've got different priorities – you've got work commitments, I had a girlfriend at the time. I didn't purposely not go and see my grandparents; it was more that I got caught up in other things. Then, when I was in my first year at university, my grandad had a stroke. It was so difficult to see because he had been such an active person.

I realise I want to spend more time with both of them. It has been a huge eye opener. They're not doing very well at the moment and it's quite scary. Not being around is something I really regret, it's just something that plays on my mind. Now I live nearer to them again, I try to make food for them and pop round and say 'hiya'. I try to reconnect as much as I possibly can.

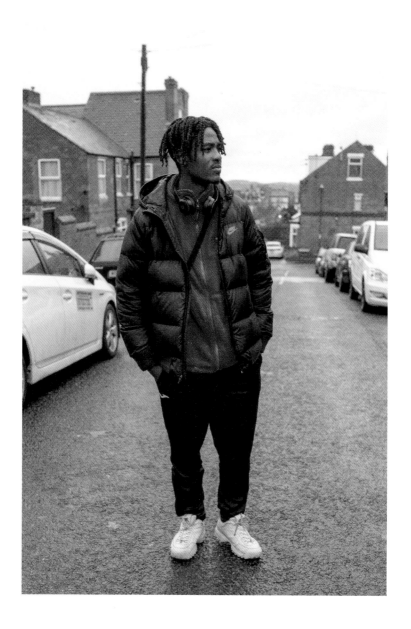

# TATENDA

I grew up living with my grandmother. We're pretty close because she was there in those early stages, which I think is so important for a young person. There's a psychologist called Mary Ainsworth, she talks about a thing called attachment theory. I do believe that in the early years of your life, if you don't have that secure attachment with one primary caregiver it affects your relationships with people in the future.

And then my grandma moved, and I lived with my aunties for a couple of years. From 5 to 15 I was just moving – living with my mum's side of the family, living with my dad's side of the family. That was quite confusing for a young person because everyone has a different way of parenting. Some of my family have a more authoritarian way of doing things, some are more flexible, some are more involved, some less involved.

I wouldn't say I had difficulties making friends, but I had difficulties keeping friendships because I was so used to moving. Even to this day I'm very cool with a lot of people. I'll find that I make friends quick but then I move them even faster. I think it starts from childhood – those early relationships are so pivotal in how you shape yourself and how you view the world. If you move a lot, you're not really going to be able to build those bonds with people.

I feel like what's missing with boys is having role models, having someone to look up to. In the 80s and 90s Black families would stay together, whereas now there's a lot of division, single mums, stuff like that. So, Black boys, they often don't have role models, they end up being lost, they don't have no one to look up to.

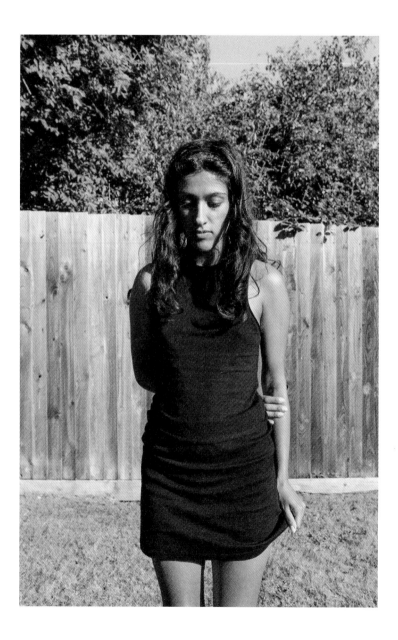

## PARV

I am beginning to understand inherited trauma and how it disrupts how families interact with each other. I've grown up around strong women, specifically my mum and her two sisters – their bond illuminated my childhood. Simply to tend to yourself is something that for the women in my family is not an option – they are expected to be orientated around caring for others and to sacrifice their own needs, which creates a system of hurt. My grandmothers were never fulfilled because their only focus was supporting others. This carried on from my grandma's generation into my mum's. As a result, it's hard for me to leave challenging situations. I punish myself for not being able to say 'No, I'm not doing this'.

The women in my family are the teachers of my life and despite the cruelty they have endured in their own lives, they are filled with so much love.

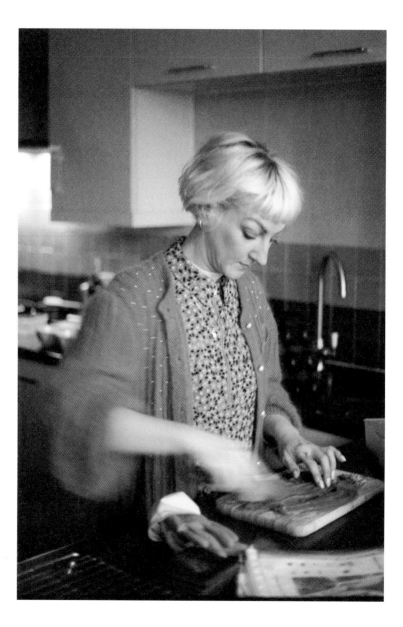

# HOLLY

Some of my fondest family memories have taken place in the kitchen. Cooking is something that has always brought my family together, providing the space for bonding, talking, laughing, learning and celebrating tradition. My father has always been at the centre of that, cooking us Polish delights to keep the traditions of his family alive. He was taught how special it was to come together as a family to eat and to put love into what you cook.

My dad lost his father at a young age. His mother, my Baba, was the heart of the home, and she was always found in the kitchen. She passed away when I was a child. I'll never forget the tiny, sharp-featured woman smoking over the stove as she slowly nurtured a pot of goulash for us all, served up with a mountain of pierogi, lashings of sour cream and pickled gherkins. I hope her recipes continue to live in my family for generations to come.

## QUESTIONS FOR SELF-EXPLORATION

What do you feel guilty about in relation to family?

What might you want to talk to a therapist about
in relation to family?

Who should you appreciate while there is still time?

Who were your role models growing up and why?

What awkward patterns of thought or behaviour
do you suffer from – and what aspect of family life
accounts for them?

To what extent has your family been a source
of support?

## ME

Tell your key story in 400 or so words.

Where would you want to be photographed?

What would your expression be?

What have you found it so hard to say in the past?

What might you want to say now?

What would you want to tell the world about family?

# PHOTOGRAPHER BIOGRAPHIES

**MARK HOBBS** (*b. London, UK, 1979*) is a documentary and portrait photographer. Through people's stories and experiences, he presents topics the viewer can relate to, learn from or disagree with, ideally causing a mild argument on the way home.
*www.markhobbsphotography.com*

pp. 44, 46, 56, 58, 60, 72, 82, 98, 106, 112, 114, 134, 166, 168

**KATE PETERS** (*b. Coventry, UK, 1980*) is interested in the intricate bonds between individuals and their surroundings. Rooted in psychological perspective, her photographic work explores issues around authenticity, community and belonging. Ultimately, she strives to capture an essence of what it is to be human, to experience.
*www.katepeters.co.uk*

cover, pp. 40, 52, 66, 70, 76, 80, 86, 96, 116, 126, 150, 154, 164

**MARJOLAINE RYLEY** (*b. London, UK, 1974*) explores ideas of memory, history, familial relationships and archival narratives in her work She uses photography, super 8, digital video, text, objects and found photographs to explore a range of themes and issues that look at linking her personal experiences to broader social and political narratives.
*www.marjolaineryley.co.uk*

pp. 38, 48, 50, 84, 110, 132, 136, 138, 142, 152

**MICHELLE SANK** (*b. Cape Town, South Africa, 1953*) is the daughter of immigrants and grew up during Apartheid, eventually settling in the UK in 1987. She cites this background as informing her interest in sub-cultures and the exploration of contemporary social issues and challenges. Her crafted portraits meld place and person, creating sociological, visual and psychological landscapes and narratives. *www.michellesank.com*

pp. 54, 74, 78, 88, 90, 100, 104, 108, 128

**NAOMI WILLIAMS** (*b. Nottingham, UK, 2000*) is a Bristol-based photographer, specialising in documentary and portrait photography. Naomi has an interest in family relationships and their complexities. She has explored her own family life and history within her work, including a series observing her grandfather in his home. *www.naomi-williams.co.uk*

pp. 42, 68, 102, 118, 124, 130, 140, 148, 156, 162, 170, 172

*Also available from The School of Life:*

## On Divorce

*Portraits and voices of separation: a photographic project*
*by Harry Borden*

**An intimate photographic study on the subject of divorce**
**by Harry Borden and The School of Life.**

Everyone wants to talk about weddings; few can bear to consider divorce. But as divorce is the ultimate outcome of around half of all marriages, the topic cries out for fresh consideration and illumination.

This is a visually captivating and psychologically stirring book that restores divorce to its deserved status as a subject of complexity and interest.

Through 48 evocative portraits and poignant interviews by the renowned photographer Harry Borden, readers are introduced to a diverse array of individuals, spanning different ages and backgrounds, whose lives have in some way been impacted by divorce.

This is a book for anyone who has ever been through divorce or might somewhere along the line encounter it – that is, for anyone who has ever dared to love.

ISBN: 978-1-915087-39-3

# The Good Enough Parent

*How to raise contented, interesting and resilient children*

Bringing up a child to be an authentic and mentally robust adult is one of life's great challenges. It is also, fortunately, not a matter of luck.

*The Good Enough Parent* is a compendium of life lessons, including how to say 'no' to a child you adore, how to look beneath the surface of 'bad' behaviour to work out what might really be going on, how to encourage a child to be genuinely kind and how to handle the moods and gloom of adolescence.

Most importantly, this is a book that knows that perfection is not required – and could indeed be unhelpful, because a key job of any parent is to induct a child gently into the imperfect nature of everything. Written in a tone that is encouraging, wry and soaked in years of experience, *The Good Enough Parent* is an intelligent guide to raising a child who will one day look back on their childhood with just the right mixture of gratitude, humour and love.

ISBN: 978-1-912891-54-2

# How to Overcome Your Childhood

*Understand the past, move on to the future*

To an extraordinary and humbling extent, who we are as adults is determined by events that happened to us before our fifteenth birthday. The way we express affection, the sort of people we find appealing, our understanding of success and our approach to work are all shaped by events in childhood.

We don't have to remain prisoners of the past, but in order to liberate ourselves from our histories we must first become fully aware of them. This is a book about such a liberation.

We learn about how character is developed, the concept of 'emotional inheritance', the formation of our concepts of being 'good' or 'bad' and the impact of parental styles of love on the way we choose adult partners. We also learn about how we might evolve emotionally and how we may sometimes need to have a breakdown in order to have a breakthrough.

We are left with a powerful sense that building up an emotionally successful adult life is possible, so long as we reflect with sufficient imagination and compassion on what happened to us a long while back.

ISBN: 978-1-9999179-9-9

# Confidence in 40 Images

*The art of self-belief*

The difference between success and failure often comes down to an ingredient that we are seldom directly taught about and may forget to focus on: confidence.

What makes one life cheerful, purposeful and energetic and another less so may have nothing to do with intelligence or qualifications; it may simply be bound up with that buoyancy of the heart and mind we call confidence.

Here is a supreme guide to this fatefully neglected quality; a series of encouraging essays that jog us into a new and more fruitful state of mind. The images that accompany the text are included to ensure that we aren't merely intellectually stirred to change our lives, but that we are also given the best kind of visual assistance.

We learn why we should dare to try, why the past doesn't have to dictate the future, why we can alter the way we speak to ourselves and why there are so many reasons to keep faith with our most ambitious aspirations.

ISBN: 978-1-915087-30-0

# A Voice of One's Own

*A story about confidence and self-belief*

This is a novel with a striking mission at its heart: not just to tell us a story, but to show us – through the example of one life – how we might change our own.

The novel introduces us to Anna, a kind, inspiring, thoughtful but modest and self-questioning person, in whom we might catch echoes of ourselves. Life has been hard of late for Anna: her job is putting her under extreme pressure, her relationship is lacking the support she craves, her parents have saddled her with a complicated emotional history. And yet she is determined to progress and liberate herself from her inhibitions.

In a style that's brief and poignant, accompanied by lyrical and thought-provoking images, we follow Anna as she unpicks the roots of her self-suspicion and discovers something we all deserve but have so often been denied: a voice of our own.

The novel amounts to a bold new kind of fiction: one that doesn't only entertain and move us, but along the way, almost without our noticing, educates and enhances us – nudging us towards new possibilities and courage for ourselves.

ISBN: 978-1-915087-26-3

## Art Against Despair

*Pictures to restore hope*

One of the most unexpectedly useful things we can do when we're feeling glum or out of sorts is to look at pictures. The best works of art can lift our spirits, remind us of what we love and return perspective to our situation. A few moments in front of the right picture can rescue us.

This is a collection of the world's most consoling and uplifting images, accompanied by small essays that talk about the works in a way that offers us comfort and inspiration. The images in the book range wildly across time and space: from ancient to modern art, east to west, north to south, taking in photography, painting, abstract and figurative art. All the images have been carefully chosen to help us with a particular problem we might face: a broken heart, a difficulty at work, the meanness of others, the challenges of family and friends ...

We're invited to look at art with unusual depth and then find our way towards new hope and courage. This is a portable museum dedicated to beauty and consolation, a unique book about art, which is also about psychology and healing: a true piece of art therapy.

ISBN: 978-1-912891-90-0

To join The School of Life community and find out more,
scan below:

**The School of Life** publishes a range of books on essential topics in psychological and emotional life, including relationships, parenting, friendship, careers and fulfilment. The aim is always to help us to understand ourselves better and thereby to grow calmer, less confused and more purposeful. Discover our full range of titles, including books for children, here:

www.theschooloflife.com/books

**The School of Life** also offers a comprehensive therapy service, which complements, and draws upon, our published works:

www.theschooloflife.com/therapy